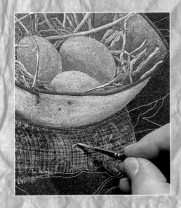

CAPTURING
TEXTURE

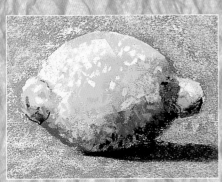

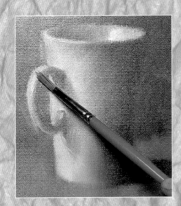

CAPTURING

TEXTURE

in your drawing and painting

MICHAEL WARR

NORTH LIGHT BOOKS
Cincinnati, Ohio

Contents

Below
HARBOUR • Richard Bolton
(watercolor on paper)
Watercolor allows the artist to depict intricate details
and textures in this harbor scene. Look at the
sand–shingle beach and the old boathouses on the right
with their weathered and worn surfaces. The combination
of these subjects produces very interesting results.

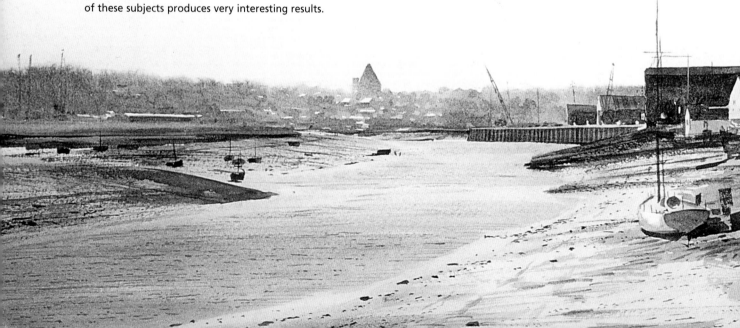

I dedicate this book to Muriel

A QUARTO BOOK

First published in North America in 2002
by North Light Books,
an imprint of F&W Publications, Inc.,
4700 East Galbraith Road
Cincinnati, OH 45236

Copyright © 2002 Quarto Inc.

ISBN 1-58180-371-0

QUAR.CATE

Conceived, designed, and produced by
Quarto Publishing plc
The Old Brewery
6 Blundell Street
London N7 9BH

Project editor Vicky Weber
Senior art editor Sally Bond
Assistant art director Penny Cobb
Designer Karin Skånberg
Photography Colin Bowling and Paul Forrester
Copy editor Sarah Hoggett
Proofreader Alice Tyler
Indexer Diana Le Core

Art director Moira Clinch
Publisher Piers Spence

Manufactured by
Universal Graphics Pte Ltd., Singapore
Printed by
Star Standard Industries Pte Ltd., Singapore

Introduction

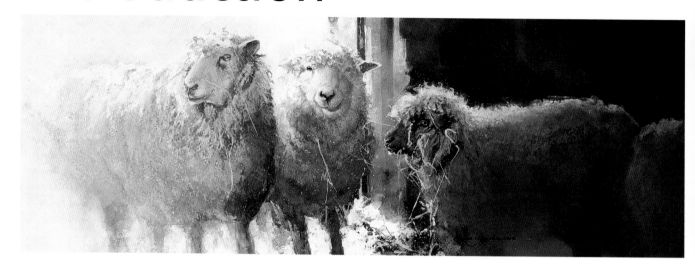

As you read this book, you might well be sitting in a comfortable armchair, sinking into deep cushions. Perhaps you have a glass of water in your hand, made from cut crystal with different facets that catch the light. Looking out of your window, what do you see? The rough-textured brick on a building or a wooden fence? A sandy beach, spiky rose bushes in your backyard, or the ruts of a plowed field?

The point is that textures are all around us, even though we are not always aware of them. But every surface has a textural quality of some description—and if you want your drawings and paintings to look realistic and really "speak" to people, then you have to learn how to convey those textures. Getting the color, shape, and form right is not enough; you need to be able to make people feel that they can reach out and touch the subjects of your paintings.

So how do you go about creating textures? First, you need to observe and analyze your subjects. When you look at something that you're going to draw, think about how it would feel if you picked it up. Would it feel heavy in your hands and be gnarled and rough like a piece of tree bark—or would it be smooth and slip through your fingers like a piece of silk? Try to understand what you're looking at before you put pen or brush to paper. The more time you spend looking, and thinking, the better.

Second, choose a medium that will help you to convey that texture. Although this is very much a matter of personal choice, understanding the different mediums is half the battle—and this book will help you to do just that.

Above

Sheep • Lynne Yancha
(watercolor and acrylic on paper)
Although most of this painting has been done in watercolor, scumbling fluid acrylic paint over the highlight areas has softened them and made it appear as if the scene is bathed in diffuse sunlight.

Texture is everywhere—you just have to train yourself to look for it.

How to Use This Book

The book begins with a brief introduction to drawing and painting materials and equipment. Take the time to read these pages, even if you think you've already decided which medium you want to use—sometimes introducing just a hint of another medium into your work will give you exactly the result you're looking for.

The second chapter looks at drawing and painting techniques and is packed with simple, easy-to-follow exercises. This gives you the chance to build up your skills and confidence on small-scale studies before you launch into a more complex drawing or painting. You can work through them page by page, or just dip in and out of the book as the mood takes you: the choice is yours.

The final chapter is based around specific themes—landscapes, buildings, trees and flowers, still lifes, animals and birds, and figures. In addition to a gallery of images by professional artists and a "Texture Notebook," in which finished images are analyzed and things that you might like to consider in your own work are pinpointed, each section contains a detailed step-by-step drawing or painting, giving you a chance to practice what you've learned.

Many talented artists have contributed work to this book, and you have a wonderful opportunity to see how different people approach drawing and painting textures. I hope they will inspire you and provide you with ideas and techniques that you can incorporate into your own work. Painting texture is a challenge for any artist, but the added realism and visual interest that textures bring to your work make it a challenge well worth undertaking.

This is a list of all the materials used in the main technique and theme demonstrations.

Step-by-step sequences provide examples of how the different techniques can portray texture.

Professional artists illustrate just what can be achieved with texture, dedication, and time.

Variations on the technique in hand give you further motivation to develop your ideas.

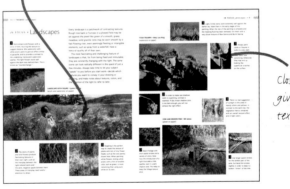

Close-up pull-outs give amazing textural details.

Color palettes indicate exactly which colors were used in the main theme demonstrations.

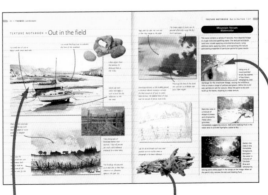

short step-by-step sequences support the main themes.

Step-by-step demonstrations of popular themes provide an in-depth study of how to achieve a finished painting.

Focusing on specific details within these sketches draws your attention to the most important textural considerations.

Use these photos for ideas about how and where to find inspiration.

Materials and Equipment

Although it's important to choose the right materials for the job at hand, you do not need specialized, technical equipment to create textures in your drawings and paintings: everyday materials, such as graphite pencils or a piece of sketchbook paper are more than adequate. After all, it's the way you use them that makes all the difference.

Remember, also, that you don't have to stick to using just one medium; it's well worth exploring other mediums to find out exactly which ones work for you. Some people have been known to slave away for years with one medium, only to discover, when they try something new, that it provides them with their ideal way of capturing certain effects.

There are a whole range of materials discussed and illustrated in this book; they include different types of drawing equipment as well as watercolor, gouache, oil, and acrylic painting equipment. In addition to these mainstream materials, many "offshoots," such as acrylic inks are available these days. If any of them appeal to you, give them a try.

Whatever you're working on, try to keep an open mind and to be creative. Experimentation is the order of the day, and the rewards can be remarkable!

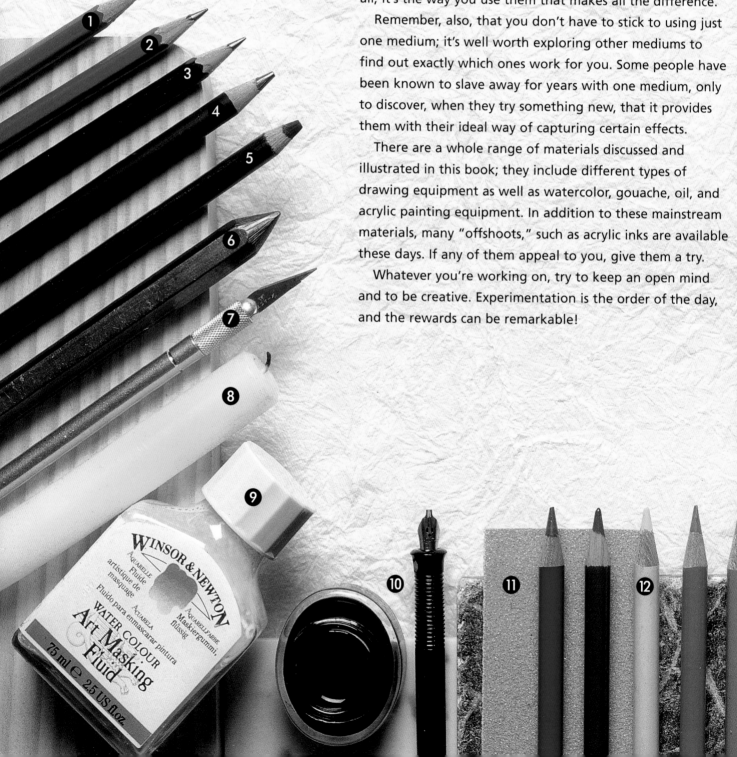

GRAPHITE PENCILS range from very hard (10H) to very soft (10B), although in practice you will probably find that you rarely use anything harder than a 5H or softer than a 7B.

The textural effects that you can create with pencils are many and varied—from soft, continuous shading through crosshatching to spiky dotted strokes. Use the tip of a sharp pencil for crisply defined lines, stroke the side of a soft pencil across the paper for smooth shading, and vary the amount of pressure you apply to create different qualities of line.

CHARCOAL is a very versatile material. If you want to achieve fluid drawing lines with differing degrees of strength—from powerful gashes to soft veils—by simply changing pressure, this is the medium for you.

PEN AND INK is a long-established drawing medium that is capable of great expressiveness and precision. Different types of pen give a different feel to your drawing: dip pens give a slightly erratic, unpredictable line, while technical drawing pens produce a smooth and uniform line, but even ordinary ballpoint pens can be used effectively.

You can brush over ink lines with water; or use a watercolor wash for a soft, colored background and draw precise pen lines on top—a technique often used to soften architectural and botanical pen drawings and prevent them from looking overly technical.

Inks are now available in a number of different colors. For black-ink work, the traditional ink is India ink, which should be diluted with distilled water. Otherwise, the pigment may flocculate, giving a mottled effect rather than a smooth, continuous line.

COLORED PENCILS are available in a vast array of colors. Use them in the same way as graphite pencils, but remember that they do not vary in hardness. You can also blend colors by laying them on top of one another.

WATER-SOLUBLE PENCILS combine the precision of pencil work with the fluidity of watercolor—a magical invention! They can be used dry, in the same way as ordinary colored pencils, and wet to give a watercolor-type effect. To use them wet, either apply them to dampened paper so that the pencil line spreads, or brush water over the pencil marks to create a wash.

1. B graphite pencil
2. 2B graphite pencil
3. 4B graphite pencil
4. 8B graphite pencil
5. Charcoal pencil
6. Solid graphite pencil
7. Craft knife
8. Candle
9. Masking fluid
10. Pen and ink
11. Sandpaper
12. Colored pencils
13. Plastic eraser
14. Kneaded eraser
15. Water-soluble pencils
16. Palette
17. Natural sponge
18. Tubes of gouache paint
19. Tubes of watercolor paint
20. Pans of watercolor paint

WATERCOLOR PAINTS are sold in tubes and pans (or half pans) and in both students' and artists' quality. If you can afford it, buy artists' quality paints, as they give better results and you generally need less paint to achieve the same density of color. Also look for paints that are 100 percent lightfast; you will find this information on the manufacturer's label.

A small range of colors is sufficient to begin with, provided the pigments are of reasonable quality. Rather than adhering to a rigid set of colors, add to the range as necessary to suit your subjects, and experiment with mixing colors yourself.

Pure watercolor paints are transparent, so when you paint one color on top of another one, some of the underlying color shows through. In watercolor painting, therefore, you have to work "from light to dark." This means you need to plan your painting before you start painting to work out where the light areas are going to be.

GOUACHE PAINTS are, like watercolor, water-based. Unlike pure transparent watercolor, however, gouache is opaque and has a matte, chalky appearance when dry. Because it is opaque, it can be used light over dark; it can also be scumbled in order to create interesting effects (see pages 56–57).

Adding gouache to watercolor paints will make them opaque, too. Good-quality white gouache is more opaque than Chinese white watercolor and will cover up any underlying paint. This is a great way of painting small highlights, rather than relying on the white of the underlying paper. You can also paint on top of white gouache in order to cover up any mistakes—though you should do this only as a last resort, as it can lead you to overwork the piece and lose spontaneity.

ACRYLIC PAINT must be one of the most versatile mediums available today. There is a vast range of colors available in both tube form and in jars.

Acrylic is a superb medium for capturing textures as it can be applied thinly or thickly, using brushes or painting knives. It dries quickly, enabling you to work speedily and spontaneously.

The quick drying time does have some disadvantages. Paint quickly hardens on the brushes and palette, so keep the brushes in water when you are not actually painting, and spray the palette with water at regular intervals.

Unlike oil paint, acrylic paint remains flexible and durable. Once it is dry, an acrylic painting on canvas can be rolled up and stored for years without the paint cracking. Acrylic paint can be used on unprimed surfaces.

OIL PAINTS You can create many different effects with oil paints, from thin, almost transparent washes and fine details to highly textured finishes. Oil paint dries slowly, allowing you time to manipulate the paint on the canvas to blend colors and tones.

Start with a small range of colors, and add more as you need them. Beware of using oil paint that contains poor-quality pigments as the colors will change considerably over a period of time.

BRUSHES for different mediums are often interchangeable (a stiff-bristled hog's-hair oil painting brush, for example, can just as easily be used with watercolor, gouache, or acrylic) and, regardless of which painting medium you prefer, it is a good idea to have a range of brushes at your disposal.

A good range to start with includes round and flat brushes in different sizes, a mop brush for laying large washes, and a script liner brush for painting fine lines and details. A couple of different-shaped palette or painting knives would also be useful for texture work.

However beguiling the art store's catalog, don't rush out and buy every size of every brush. A small, medium, and large brush in the main types is plenty with which to begin. As with paints, buy the best you can afford; buying inexpensive brushes is a false economy, as they quickly wear out and often shed hairs.

SOFT PASTELS are made from finely ground pigments mixed with chalk or clay and then bound with gum arabic. They are opaque, which means they can be worked light over dark; they can also be applied to a wide range of colored surfaces, even very dark ones.

Pastels are a good choice for capturing textures. Because they are soft, you can easily blend them to create smooth, flat textures. You can also sharpen them with a craft knife to draw fine details. When used on rough paper, you can create lovely broken textures as the pigment sits on the raised parts of the paper, leaving the "troughs" free of color.

To prevent smudging, always spray pastel drawings with fixative. (Don't forget—you can even use hairspray as a fixative!)

OIL PASTELS are a relatively recent development, allowing you to use oil paint in stick form. You can blend oil pastel marks by rubbing them with a rag for a smooth texture and subtle colors, or apply them thickly for an impasto effect. Like conventional oil paints, they take a long time to dry.

1. Pot of acrylic paint
2. Tubes of acrylic paint
3. Tubes of oil paint
4. Painting knife
5. Palette knife
6. Wooden palette
7. Turpentine
8. Linseed oil
9. Bristle brushes: round, flat & filbert (shaped)
10. Small, round acrylic brushes sizes 1, 3 & 5
11. Round and flat watercolor brushes sizes 6, 5, 4, 3, 2 & 1
12. Liner brush
13. Soft hake brush
14. Oil paint stick
15. Wax oil crayon
16. Oil pastels
17. Soft pastels: round & square
18. Chalk
19. Torchon
20. Pastel pencils

Surfaces

Surfaces (also known as "grounds" or "supports") play an important role in drawings and paintings about texture, and the surface you choose has a tremendous influence on the final appearance of your work.

There are distinct differences between surfaces. Some surfaces are totally unsuitable for certain materials or mediums, and your choice will be dictated, at least in part, by the medium you are using. Think, too, about the subject you're depicting and about what texture might be appropriate for it. For example, a watercolor of a rough-textured subject, such as tree bark, cries out to be painted on a rough surface, while a gessoed surface might be more sympathetic than a rough canvas for an oil portrait of a smooth-skinned baby. Sometimes artists deliberately choose an unexpected surface in order to obtain unusual results, so try not to get too set in your ways.

Let's take a look at some of the surfaces that are available to us and at the different textural qualities that they possess. This will help you to make an informed choice about which surfaces to use.

WATERCOLOR PAPERS are available in three main types: hot-pressed (HP), cold-pressed (CP) or "Not," and rough. Hot-pressed paper has a very smooth surface and is good for subjects that require fine detail while, at the other extreme, rough paper has a pitted surface that is perfect when you want a broken texture.

Watercolor papers also come in different weights, or thicknesses. The standard weights are 90 lb (190 gsm), 140 lb (300 gsm), and 300 lb (640 gsm). Lightweight papers (those below 140 lb/300 gsm) should be stretched before use. Otherwise they will buckle when water is applied.

Experiment with different papers from different manufacturers so that you know the pros and cons of each and can choose one that suits your subjects and aims.

PAPERS FOR DRAWING AND PASTEL WORK Good-quality drawing paper is suitable for many different drawing mediums—graphite, colored pencils, and charcoal. It is usually fairly smooth, which makes it a good choice for linear work. It is best to use a reasonably heavy paper for texture work, as you often need to apply more pressure to the drawing tool.

For drawings in ink or ones that incorporate watercolor washes, however, a watercolor paper is generally better, as it will not crinkle when damp.

1. 120-lb (250-gsm) very, very rough watercolor paper
2. 300-lb (640-gsm) rough handmade watercolor paper
3. 300-lb (640-gsm) handmade watercolor paper
4. 300-lb (640-gsm) cold-pressed watercolor paper
5. 120-lb (250-gsm) cold-pressed watercolor paper with deckle edges
6. 120-lb (250-gsm) hot-pressed watercolor paper
7. 120-lb (250-gsm) cold-pressed textured watercolor papers
8. Tinted watercolor papers
9. Illustration board
10. Good-quality drawing paper
11. Colored papers
12. Colored papers
13. Colored pastel papers
14. Pastel papers with textured surfaces (gritted or velvety)

❶

❷

❸ **❹** **❺**

Illustration board is a good choice for colored pencil work, as many layers of color can be applied without damaging the surface. Detailed, textured drawings often rely on multilayering and much pressure.

A good-quality pastel paper normally has a "tooth," or light texture, which enables the pastel pigment to adhere to the surface efficiently. Pastel paper is also a good choice for charcoal and chalk work. Pastel papers are produced in a wide range of colors, and the color you choose depends on both the subject and the mood or atmosphere of the work.

SURFACES FOR OILS AND ACRYLICS All surfaces for oil painting must be primed before use. Otherwise the oil content of the paint will spread away from the pigment and the color will sink into the surface.

For oil painting, you can buy ready-primed sketching papers, painting panels, and canvases, which are convenient but expensive. Alternatively, you can prime your own using proprietary primers available from art-supply stores.

You can also buy ready-primed surfaces for acrylic painting. Just make sure they have been primed with acrylic primer, not oil-based primer, as acrylic paint does not adhere to any surface that contains oil or wax.

Gesso, a form of plaster, is a traditional surface for both oils and acrylics. Apply several layers of it over a rigid surface, such as marine plywood, medium density fiberboard, or thick hardboard or masonite, allowing each layer to dry thoroughly before you apply the next one. The first layers of paint sink into the gesso, bonding with the surface rather than just sitting on it.

Colored paper is also available for gouache and acrylic painting. The opaqueness of the paint covers the darkest of colors with ease.

SKETCHBOOKS Use a sketchbook to test out ideas for drawings and paintings and to collect visual material for future reference. A sketchbook is like an old friend—it can always be relied upon!

1. Ready-primed stretched canvas panel
2. Gesso-coated medium density fiberboard
3. Fine acrylic sketching paper
4. Medium acrylic sketching paper
5. Canvas paper
6. Medium oil sketching paper
7. Coarse/rough oil sketching paper
8. Fine canvas panel
9. Rough canvas panel
10. Sketchbooks
11. Drawing pad for sketching

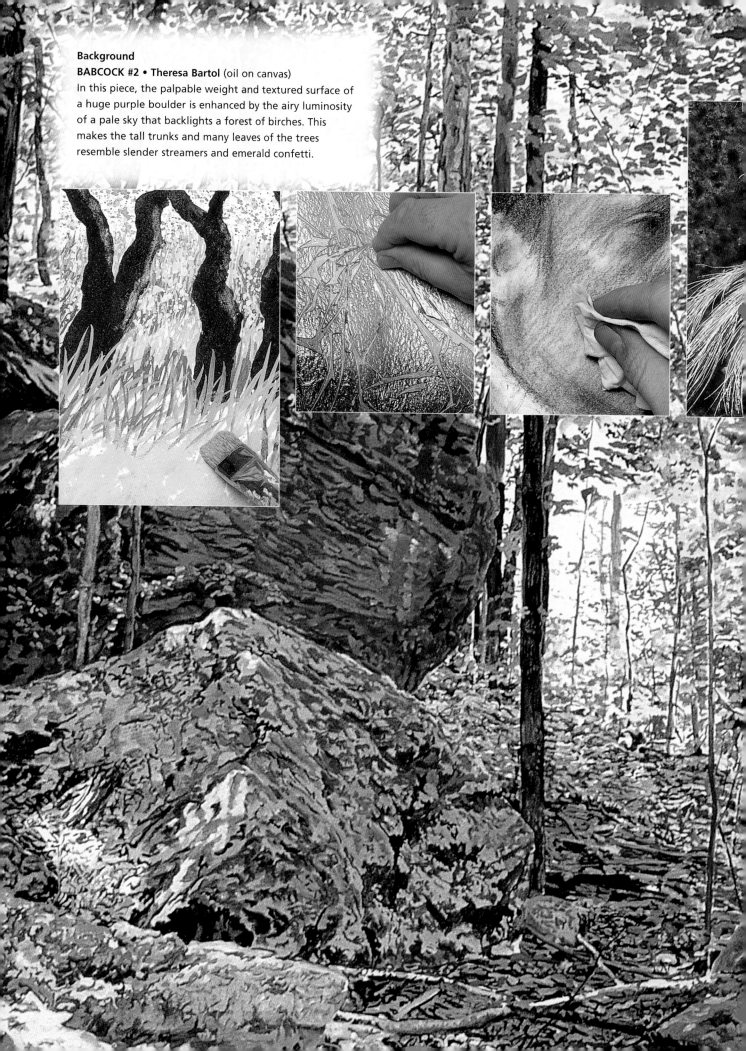

Background
BABCOCK #2 • Theresa Bartol (oil on canvas)
In this piece, the palpable weight and textured surface of a huge purple boulder is enhanced by the airy luminosity of a pale sky that backlights a forest of birches. This makes the tall trunks and many leaves of the trees resemble slender streamers and emerald confetti.

Before you embark on textural work, it's a good idea to master some basic techniques. Any skill relies on knowing the basics (learning scales, for example, helps us get a thorough grounding in music), and drawing and painting are no exception. Improving your confidence is the all-important factor: by practicing simple techniques, and building on what you learn, you'll eventually be able to produce successful, highly-finished works.

TECHNIQUES

Remember, an art tutor can show you techniques and give you tips and advice, but practice is the only way to improve and gain experience. So, if you feel daunted when you look at a complex, detailed painting and think, "I'll never be able to paint like that!", don't give up. Patience is the key: remember—Rome wasn't built in a day!

The practice exercises suggested here shouldn't feel like a chore; try working some of them into finished pieces, and allow the process of creating texture to become exciting and fulfilling. Enjoy texture for its own sake!

graphite pencils and solid
graphite stick

Drawing Mediums

Drawing mediums are relatively inexpensive, so you can experiment with different materials without breaking the bank. And the choice is fantastic!

There are graphite pencils of differing degrees of hardness, which allow you to make a whole array of marks in the same drawing; charcoal sticks in varying shades of black and brown for wonderfully fluid lines; graphite powder for swirling smudges. Even everyday writing tools that you might not have considered using for drawing, such as ballpoint and felt-tip pens, can create interesting effects and textures. And you are not restricted to monochrome: water-soluble pencils and crayons are available in a vast range of colors, as are colored chalks and oil pastels.

Below
RED MAPLE IN THE FOG • Bill James
(pastel on paper)
The glow on this red maple, seen against fog, relies on the stippling technique. Note how the textured, fall leaves are built up from the dark, silhouetted branches to the final, very light effect.

set of oil pastels

set of soft pastels

soft pastels

water-soluble
pencils

oil pastels and
wax oil crayon

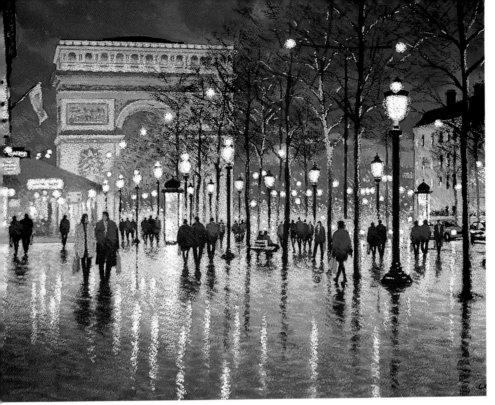

Left
CHAMPS ELYSÉES • Michael Lawes
(pastel on gouache)
Bright lights reflected in the glistening, wet sidewalk perfectly capture the atmosphere of a city at night in this study. The paper was toned in blue gouache paint to convey the deep blue of a sky at dusk. Light pastel colors were applied over the top to create the reflections while allowing the underlying color to show through.

colored pencils

If you're on a tight budget, or don't want to risk buying something that you might not enjoy using, almost all of these items can be bought individually, rather than as complete sets. So you can try one or two to find out what you like, and then build up a set slowly.

You cannot have too much drawing equipment, and it's wonderful to be able to gauge the changes—the more you experiment, the better the final results will be.

charcoal sticks

pastel pencils

Right
FACE • Mark Topham (graphite pencil on paper)
The human face provides excellent subject matter for capturing detail and texture. Take every opportunity to sketch or draw relatives and friends—the practice is invaluable.

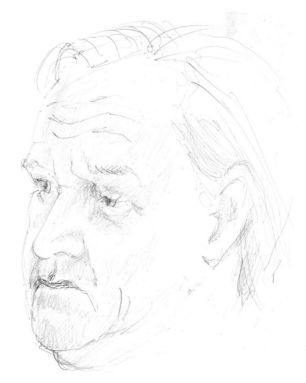

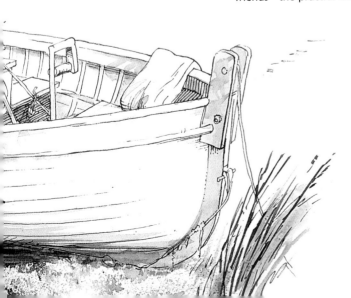

TECHNIQUE 1 • Hatching

Materials

- Good-quality drawing paper
- Range of colored pencils
- HB pencil
- 4B pencil

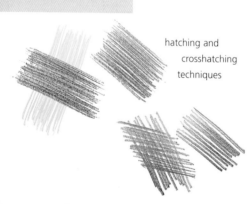

hatching and crosshatching techniques

Hatching is the term used to describe parallel lines drawn close together at the same angle. Hatching is used for shading, and it is probably the most fundamental of all drawing techniques. Although it is simple to do, practice is essential and it is worth spending time creating hatched lines for their own sake. Crosshatching—two sets of parallel lines, one on top of the other, with the second set at an angle to the first—is a variation on the basic technique.

Hatching the background

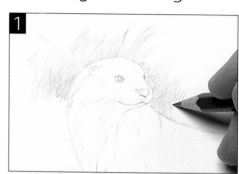

Using an HB pencil, sketch the basic outline of an otter. Switch to a 4B pencil and begin hatching the background.

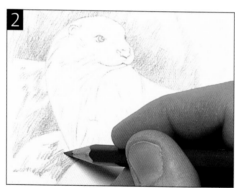

Continue hatching the background. Work carefully around the otter, trying not to go over the outline and onto the otter itself.

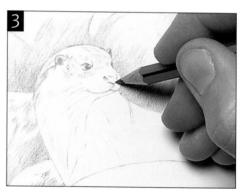

Switch back to the harder HB pencil and begin to add details to the otter's face, making sure the details are sharply drawn.

Other Subjects For Hatching

Egg

Although the surface of an egg is smooth, you can convey its form by varying the intensity of your hatching and crosshatching for shaded and highlight areas.

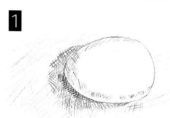

Outline the egg in light gray pencil and crosshatch the darker side in blue. Hatch the background in light brown and crosshatch the shadow in dark brown, adding blue and purple immediately beneath the egg.

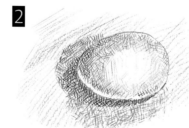

Reinforce the form of the egg by crosshatching in dark brown and ocher. Use these colors to intensify the shadow. Leave space for the highlight in the egg's center.

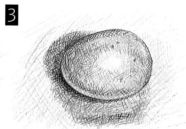

Continue hatching both the egg and the surface with green and purple to make the egg stand out from the background and appear more solid.

Hatching to create form

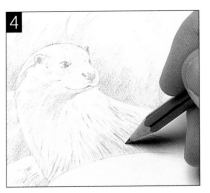

4

Still using the HB pencil, finish adding the details to the otter's face and body.

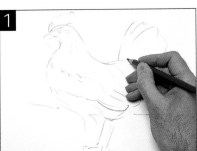

1

Sketch the outline of a hen using light colored pencils.

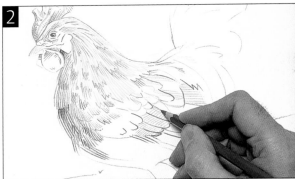

2

Select a range of colored pencils (a light, a middle, and a dark tone) for each area. Hatch each area, making sure the pencil strokes follow the form of the subject.

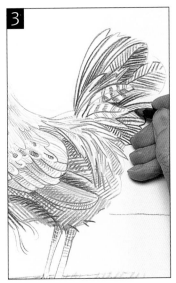

3

Continue to build up the drawing in this way, varying the pencil pressure and using crosshatching for the areas that are in shade or have the densest texture.

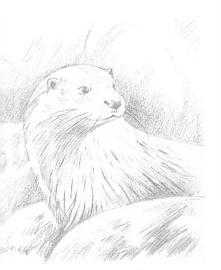

Hatching the background has allowed the subject to stand out clearly; and because it is hatched, rather than shaded solidly, there is a clear suggestion of texture.

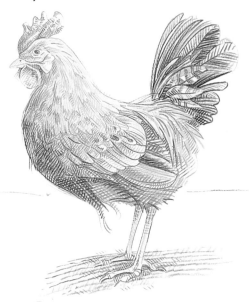

Careful hatching within each area has created a range of textures. Varying the direction of the lines in different parts has helped to convey the form of the bird.

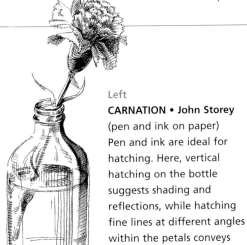

Left
CARNATION • John Storey
(pen and ink on paper)
Pen and ink are ideal for hatching. Here, vertical hatching on the bottle suggests shading and reflections, while hatching fine lines at different angles within the petals conveys their crinkled texture.

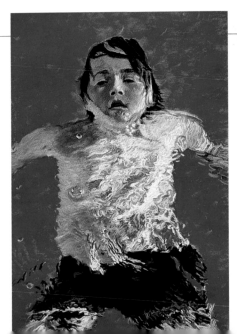

Right
BRYAN IN THE POOL • Bill James
(pastel on paper)
Hatching is used well here to depict the fragmentation of images below the surface of water and the ripples in the water itself. The horizontal pastel strokes in the water and over the boy's body help to convey a feeling of fluidity, contrasting with the more solid shape of the boy's head above the water's surface.

TECHNIQUE 2 • Continuous Shading

Materials

- Good-quality drawing paper
- Range of (water-soluble) colored pencils
- HB pencil
- 2B pencil
- 4B pencil
- B graphite pencil
- Kneaded eraser
- Soft cloth

Most subjects require shading in order to describe their form and texture. In continuous shading, the pencil lines follow the shape of the subject, revealing its three-dimensional form and textural qualities. Study your subject closely, and work out where the light and dark tones should fall before you start a drawing. Softer pencils are better suited to this type of work, and varying the pressure of the pencil is recommended in order to create different shades of light and dark.

shaded lines made with graphite pencils in a variety of tones

Shading a crumpled subject

Using an HB pencil, draw the subject accurately.

Using a kneaded eraser, rub down the tone of lines, leaving a ghostly image.

Still using the HB pencil, lightly shade the areas that are in shadow.

Other Subjects For Continuous Shading

Cushions

Using the side of colored pencils, rather than the tip, makes it easier to create large areas of continuous tone—perfect for these soft fabrics. Details such as the creases and shadows can then be intensified by using the tip of the pencil, creating an interesting contrast.

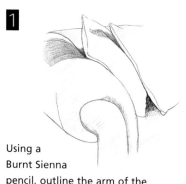

Using a Burnt Sienna pencil, outline the arm of the sofa and the cushions. Lightly color the sofa arm in loose strokes of Burnt Umber.

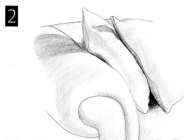

Using the side of the pencil, lay Yellow Ochre over the previous color, lightening the pressure for the highlight areas. Add purple to the deep shadows.

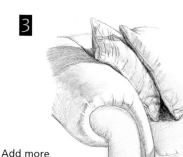

Add more detail in Burnt Umber, increasing the pressure to make the color darker. Note how the textured, stitched area comes to life, adding further interest to the study.

Half-close your eyes to make it easier to see the differences in tone, but do not worry about fine detail at this stage; continue shading, applying a little more pressure to the pencil.

Using a 4B pencil, shade around the right-hand and bottom edges. This implies that the paper is casting a shadow onto the surface on which it sits, thus enhancing the three-dimensional effect.

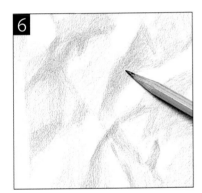

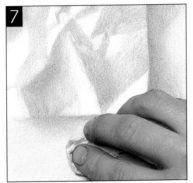

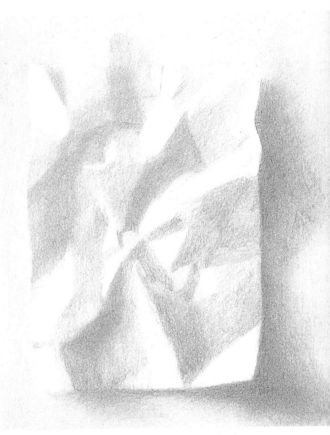

Add a little more shading to the drawing, creating greater contrast.

Using a soft piece of clean cloth, smudge the shading around the right-hand and bottom edges of the paper to soften it.

Crumpled paper has many different planes, and using continuous shading to shade some areas while leaving others completely blank illustrates this beautifully.

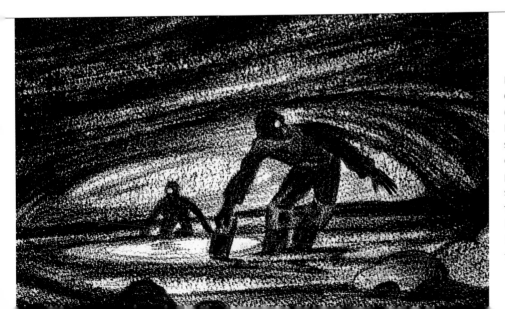

Left
CAVERS IN A LOW PASSAGE • Robin Gray
(black chalk on watercolor paper)
In this drawing, the continuous chalk strokes provide dramatic shading, while dragging chalk over rough watercolor paper creates the broken texture. The same broken effect is also employed in the water, creating reflections from the light of the cavers' lamps. Note how the light areas provide an excellent foil for the dark, silhouetted cavers.

TECHNIQUE 2 • Continuous Shading

Shading a smooth-surfaced subject

Using an HB pencil, carefully draw the outlines and inside of a capsicum.

Change to a 2B pencil, and begin shading the outside of the capsicum with long strokes.

Shade the inside of the capsicum to reveal the shapes and forms. Remember to change the pressure on the pencil from time to time to add interest to the drawing.

Shade in a shadow under the capsicum in order to anchor it to the surface. Otherwise, it will appear to be floating in space.

The gentle, continuous shading in this drawing conveys the texture of the capsicum's skin, which is smooth and shiny.

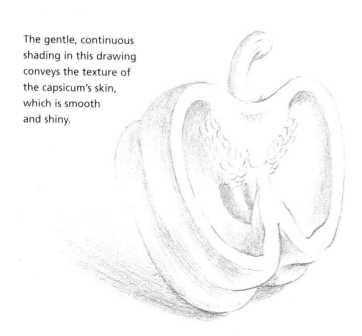

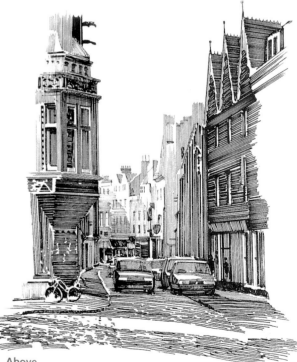

Above
STREET SCENE • Richard Bolton
(pen and ink on drawing paper)
Here, closely drawn pen lines provide an excellent way of conveying light and shade on formal buildings and surrounding subjects. The textured street cobbles are created in the same, closely drawn manner.

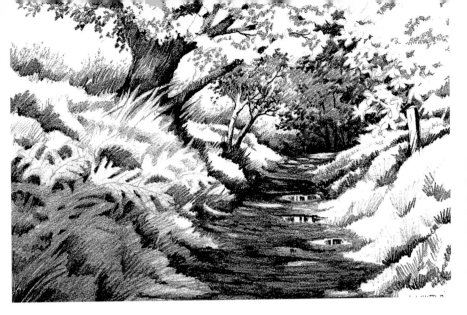

COUNTRY LANE • Janet Whittle
(graphite pencil on drawing paper)
Continuous shading works very effectively in this piece to describe contrast. Dark and medium tones in both the hedgerow and the pathway are hatched with a 6B pencil. The puddles with refelctions add extra interest to this pleasing composition.

Continuous shading in color

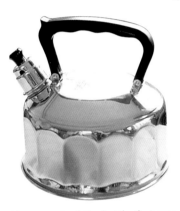

Photograph of the kettle that was the actual subject.

Using a B graphite pencil, very lightly draw the outline of a kettle.

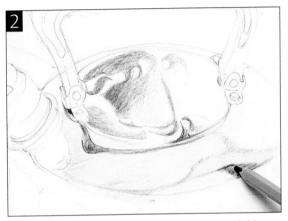

Switch to colored pencils (these can be water-soluble pencils), and begin shading the top of the kettle. Work around the shapes of the reflections using dark blue, blue-black, and brown-red pencils.

Define the handle with black and dark blue, using black to create the outline and dark blue to shade within each shape.

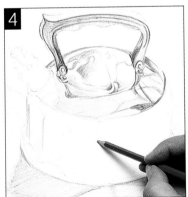

Using an ocher pencil, continue to shade, keeping the pressure light and working downward onto the side of the kettle. Indicate each facet on the lower part of the kettle with a strong vertical line. Loosely sketch the cast shadow to the left of the kettle.

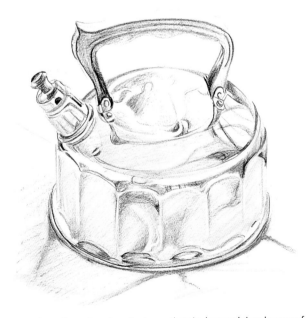

Strengthen the colors by glazing—that is, by applying layers of color, one on top of another. Use Burnt Sienna and Venetian Red over blue for "warm" areas, and draw details in dark blue and black. Continuous shading using long pencil strokes portrays the smooth, shiny surface very convincingly.

TECHNIQUE 3 • Stippling

Materials

- Good-quality drawing paper
- Colored pencil
- HB pencil
- 2B pencil

Stippling is used both to create texture and to produce shading. It involves placing a series of dots close together or farther apart, depending on the effect that is required. Both pencils and pens lend themselves well to the technique. You can control the size of the dots by using pens of differing nib sizes, or harder or softer pencils (the harder the pencil, the sharper the point you can achieve and the smaller the dot).

stippled dots produced with various-sized pens

Stippling a crumbling subject

Using an HB pencil, draw the outline of a loaf of bread.

With a 2B pencil, begin shading the outer crust—lightly at first, and adding pressure at the bottom.

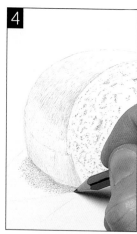

Begin stippling the bread on the inside of the loaf. Use small dots initially, and then stipple closer together, gradually forming the groups of dots into the shapes of the crumbly bread texture.

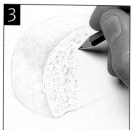

Stipple the shadow of the loaf, applying more pressure to the pencil.

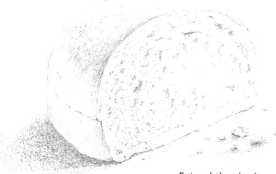

Extend the shadow, spacing the dots farther apart and reducing the pressure so that it appears to fade. Add some crumbs in the foreground to complete the drawing. Stippling enhances the effect of a crumbly surface—the areas appear to be "broken."

Other Subjects For Stippling

Lemon

Lemons and other citrus fruits have pitted skins. Stippling a darker tone or color on top of a light one is the ideal way to convey this. The rough paper surface also echoes the lemon's texture.

Using the side of soft pastels, block in the lemon with Lemon Yellow, Cadmium Yellow, and Burnt Sienna. Spray with fixative.

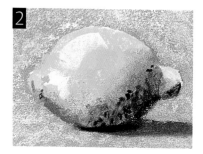

Consolidate the fruit's colors and tones, block in the background with a light gray. Begin to build the skin texture by stippling dark brown on the underside to suggest shadow.

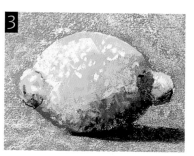

Layer light orange and Burnt Sienna in the shaded area, together with a little dark purple. Finally, stipple on white to create the highlights. Spray with fixative.

Soft-piled velvet

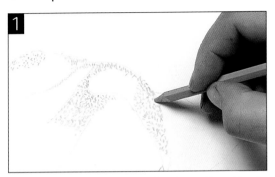

Make a loose sketch with a colored pencil, and begin stippling. Apply the dots with a slight horizontal movement in order to give them impact.

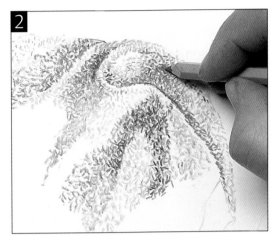

Overlay several tones of the same color, particularly in the shadow areas. Folds in fabric offer great opportunities for exploring differing tonal values from very light to dark. Stippling allows a gradual and very subtle transition from one tonal value to the next.

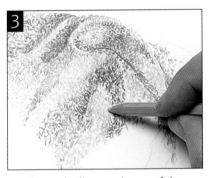

Continue stippling, paying careful attention to the changes in tone caused by the way the light hits the fabric.

Stippling is a perfect way of conveying the texture of velvet. Changes in tone can be described very precisely, while varying the size of the dots helps to depict the smooth, slightly raised pile of the fabric.

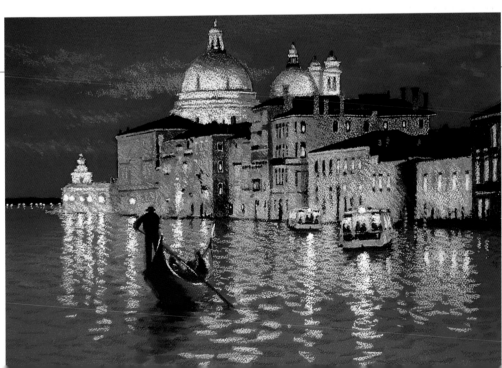

Right
GRAND CANAL AND THE SALUTE •
Michael Lawes
(pastel on paper)
There are some stunning examples of stippling in this pastel piece. The technique was used effectively on the dome, in the sky, and in the reflections in the water, and provides not only texture but also visual mixtures of color.

TECHNIQUE 4 • Smudging

Materials

- Good-quality drawing paper
- Tinted pastel paper
- Charcoal pencil
- 4B pencil
- Range of oil pastels
- Soft tissue paper
- Kneaded eraser

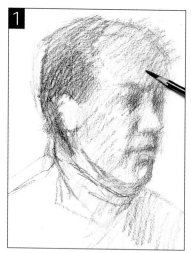

smudged pastel marks

Smudging is best suited to soft drawing materials such as soft pencils, charcoal, chalk, soft pastels, and oil pastels. You can use any type of material to smudge the marks (a piece of soft cloth, or paper towel, for example), but many artists prefer to use their fingers. Smudging is an ideal way of conveying soft texture. It is also an excellent method of blending or mixing colors on a surface. One word of warning: it is very easy to oversmudge, creating muddy color or tone. So make sure you smudge lightly to begin with and avoid overworking the area.

Smudging for shading

Using a charcoal pencil, sketch the initial shapes and indicate the light and dark tones. This creates the basic forms.

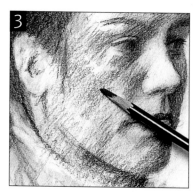

Use soft tissue paper to soften the charcoal marks and lift out the highlights. Smudging blends the tones ready for the next stage.

Continue shading, using the charcoal pencil and short hatching strokes and applying a little more pressure for darker tones. Smudge again with soft tissue paper to blend the tones.

Other Subjects For Smudging

Cowrie shell

Smudging soft pastel is the perfect way to blend colors and convey the smooth, shiny surface of this cowrie shell. Sharper lines around the edges provide visual contrast and allow the shell to stand out from the background.

Draw the shell outline in blue. Apply Yellow Ochre on the top, leave the highlights white, and shade the underneath blue and purple. Smudge the colors together with your finger.

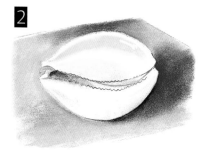

Continue introducing color on the shell and background, smudging with your finger to blend the tones. Add sharp lines of purple and blue to define the opening of the shell.

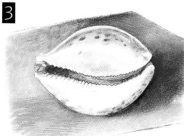

Strengthen the outline by working around the background. Draw the pattern in browns and purples, blend the color with your finger. Finally, rework the highlights in pure white.

Lift out the highlights with a kneaded eraser and the drawing of Sally is complete. Smudging is a wonderful technique for adding overall unity to a piece of work.

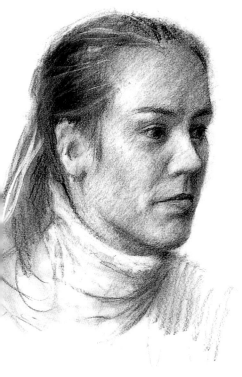

Smudging the background

Using a 4B pencil, draw a rose on tinted pastel paper.

Hatch in the background with yellow, light green, and dark green oil pastels and smudge the colors in horizontal streaks with your finger to create an "out-of-focus" look.

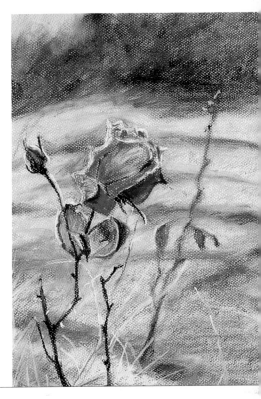

Using a dark green oil pastel, draw a rose stem and bud. Smudge the lines with your finger, so the image blurs.

Color the foreground rose and leaves in oil pastel, but do not smudge. Apply oil pastel strokes on the rose, keeping the pressure strong. The smudged background lets the flower stand out.

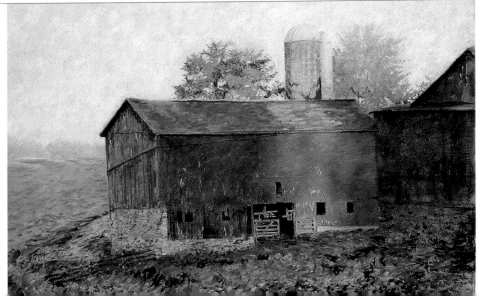

Left
BARN OUTSIDE WATERFORD • Bill James
(pastel on paper)
The artist smudged several pastel colors together on the side wall of the barn to create not only a smooth texture but also the late-afternoon glow of light.

TECHNIQUE 5 • Using a Torchon & Kneaded Eraser

Materials

- Good-quality drawing paper
- Range of soft pastels
- 4B pencil
- Graphite stick
- Torchon
- Kneaded eraser
- Spray fixative

A torchon is a tightly wound stump of paper. You can buy one from an art shop; or simply use a cotton bud or tightly rolled absorbent paper. You use it to lift out highlights, smudge, and blend soft materials such as graphite pencil, pastel, and charcoal. It is easier to control than a finger, so you can create fine smudges or lift off in small areas.

kneaded eraser

torchons—also known as tortillions and tortillons

Torchon for blending and lifting

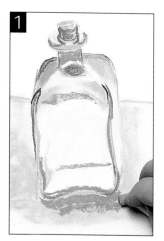

1

2

3

Using the torchon, gently smooth the soft pastel marks to create gradations of tone.

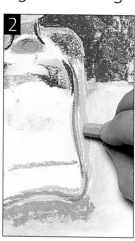

4

Using soft pastels, establish the shape of the bottle. Constantly blow away the dust to avoid smudging the colors.

Add a background and surface; the background defines the bottle and the surface places it in context.

Shape a kneaded eraser to a point and gently lift off the highlights. Finally, fix the work with spray fixative. The torchon blends the colors more subtly than you can with a finger, and it lifts the highlights neatly.

Other Subjects For Using a Torchon

Bucket

With a soft, powdery medium such as pastel, it can be hard to keep the highlights free of pigment. So, apply tone over the whole area and use a torchon to lift off color for the highlights. This is most useful for smooth-surfaced, rounded objects, such as the bucket shown here.

1

2

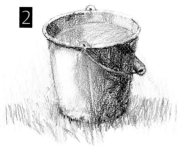

3

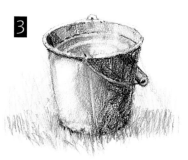

Block in the shapes and tones of the bucket in Light Warm Gray and Dark Warm Gray and Yellow Ochre pastel pencil. Color the surface of the water, which reflects the sky, in Cerulean Blue.

Continue to build up the tones. Use a torchon to wipe off some of the color on the left-hand side, creating the impression of light shining on the surface. Sketch the grass in greens.

Darken the water on the shaded side with Dark Warm Gray and add Cerulean Blue on the lighter side. Stroke a torchon over the water to lift off color and suggest ripples.

graphite sticks

Torchon for smoothing and spreading

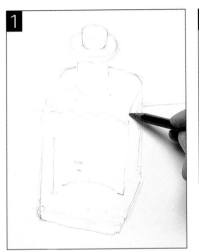

1

Using a 4B pencil, draw the outline of the bottle.

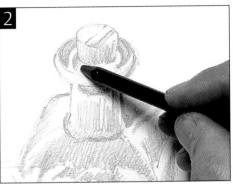

2

Still using the 4B pencil, hatch the bottle and stopper to convey their form.

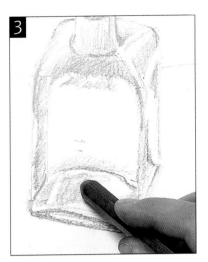

3

Use a graphite stick to hatch the base of the bottle and the surrounding surface: it's softer than a 4B pencil and allows you to cover a larger area more quickly.

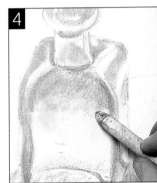

4

Use a torchon to smooth and spread the pencil strokes.

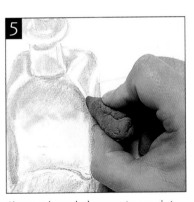

5

Shape a kneaded eraser to a point and use it to lift off the highlights.

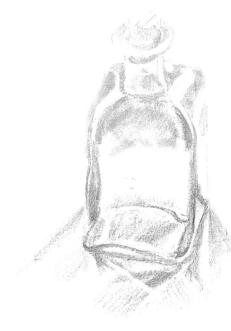

Complete the drawing by adding a few sharp lines with a 4B pencil to sharpen definition on the bottle. The torchon smooths and spreads the pencil marks in a neat, clean fashion.

Right
WALLINGFORD BRIDGE • Ron Ripley
(pastel on paper)
Here, the artist used a torchon to lift out highlights on the water and create the reflection of the boat.

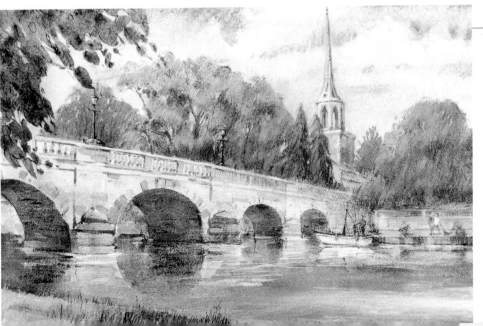

TECHNIQUE 6 • Details

Materials

- Good-quality drawing paper
- HB pencil
- 2B pencil
- B pencil
- Range of colored pencils
- Range of soft pastels
- Medium-nibbed dip pen
- Fine-nibbed technical drawing pen
- India ink
- Non-absorbent paper

Observing details in your subject is an essential part of capturing texture—and the best way to observe something is to make a drawing of it. Detail and texture are synonymous; you can use any fine drawing medium—graphite pencil, pen and ink, well-sharpened pastel pencils—to record them. Good drawings will always provide an excellent source of information from which you can make highly finished detailed and textured paintings later on.

Details in pastel and colored pencil

1

2

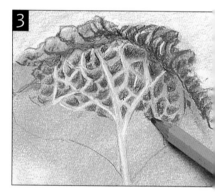

3

Using soft pastels, establish the broad shapes and areas of color of the cabbage. Keep it smooth by rubbing the pastel marks with your fingers.

Using a white colored pencil, indicate the network shapes in line only.

Using a dark green pencil, fill in the areas between the light network shapes.

Other Subjects For Details

Eye

Drawing a small subject that contains a lot of detail is a great way of improving your observational skills. Here, the use of color makes the painting more interesting.

1

On smooth, good-quality drawing paper, lightly draw the outline of the eye in Burnt Sienna, violet, light purple, light pink, and white.

2

Slowly build up the color, applying slightly more pressure and making sure your pencil strokes follow the subject's form. Use pale blue (for the white of the eye), gray, and salmon.

3

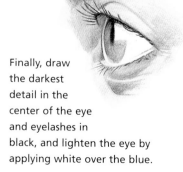

Finally, draw the darkest detail in the center of the eye and eyelashes in black, and lighten the eye by applying white over the blue.

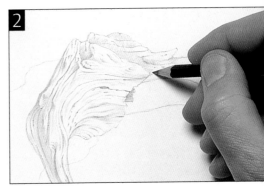

Continue with this technique on the other side of the leaves and add some details to the curly tops.

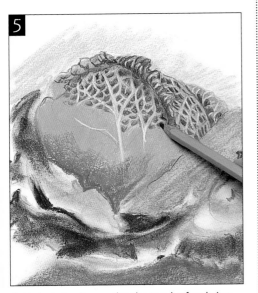

Add dark shading under the top leaf to bring it forward and make it stand out. You could use the same techniques on any subject of similar complexity.

Fine detail with graphite pencil

Using an HB pencil, sketch the outline of the driftwood and begin to draw the splits and grain. Do not be afraid to exert pressure on the pencil.

Draw the nearer section first, paying attention to the knots and other details.

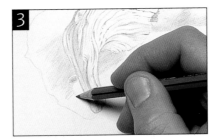

Using a 2B pencil, draw the section that is farther away; this needs to look slightly "out of focus" and the softer pencil is better for this. Begin shading under the driftwood, using soft hatching.

Complete the shadow, taking care not to create an outline around it as this will render it less convincing. Drawing and observing detail in this way will ensure that skills are gained not only in looking but in **seeing**.

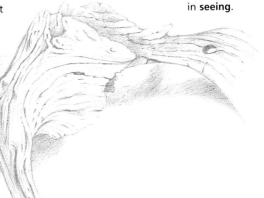

Top right opposite page
NARROW PASSAGE • Richard Bolton
(pen and ink on paper)
Architectural details are always a challenge. Here, the artist has put pen and ink to excellent use, using hatching to convey the textures of the different types of stone. Fine pen work is always suitable for depicting detail; even the bicycles in this drawing can be clearly seen amidst the collection of buildings.

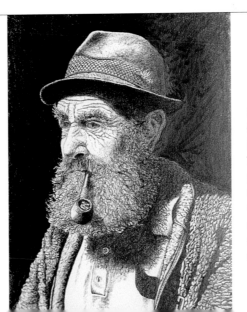

Left
GERTCH • Michael Warr
(graphite pencil on paper)
The face, hat, jacket, and beard provide wonderful opportunities for exploring detail and texture. The subject stands out well against the dark background, focusing attention on the different textural details within the portrait.

TECHNIQUE 6 • Details

Texture and detail in ink

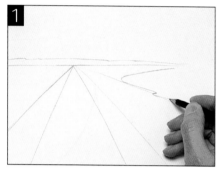

Using a light B pencil, draw the perspective of the beach and the distant horizon.

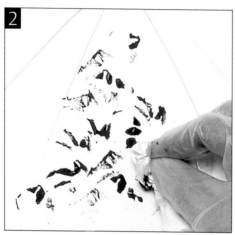

Dip non-absorbent, crumpled paper in India ink and print random marks on the shadow side of the rocks. Twist the paper as you go, so that there are not too many repeated shapes.

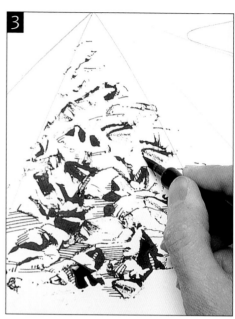

Using a medium-nibbed dip pen, indicate lines on the light side of the rocks. Use the back of the nib occasionally to create more random marks.

Right
RIVER AND TREES • Richard Bolton
(pen and ink)
The detailed tracery of the trees is captured with ink lines; the textures of the river banks are achieved by using crosshatched ink lines; and there is also a small amount of watercolor wash work. All of these features combine to provide a good, finished piece of work containing excellent information.

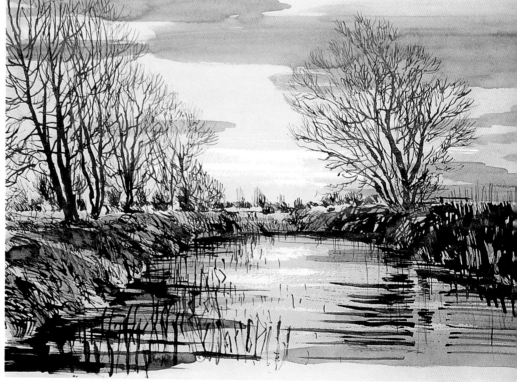

Include some hatching and dots among the rocks to create texture.

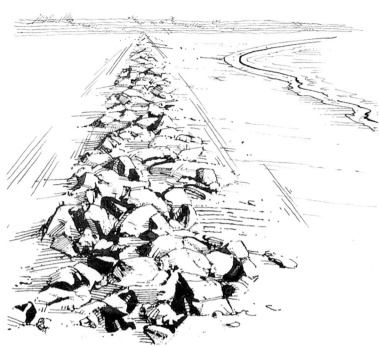

Using a fine-nibbed technical drawing pen, draw lines in the background. The change in scale suggests distance.

When the ink is dry, rub out the pencil lines. The drawing is complete. The combination of random marks and carefully drawn areas gives the drawing a convincing, natural look.

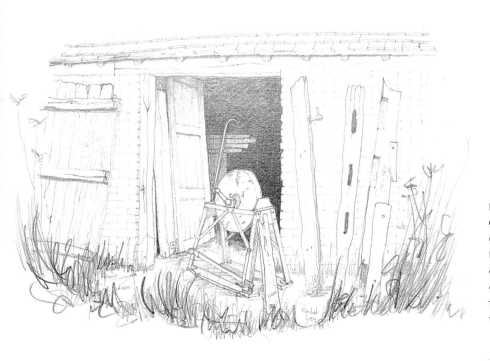

Left
GRINDING WHEEL • Michael Warr
(graphite pencil on paper)
In this work, detail and texture are captured using a 4B pencil. Note how the dark tonal values inside the building help to define the overall form of the old, worn grinding wheel.

TECHNIQUE 7 • Colored Surfaces

Materials

- Dark blue pastel paper
- Beige pastel paper
- Range of soft pastels
- Range of pastel pencils
- Kneaded eraser
- Piece of thick paper or card

The choice of colored surfaces (grounds) is endless, and you can use any drawing medium on them. Depending on the color, the effects you can achieve range from somber and muted to stunning and dramatic. The most important thing to bear in mind is that, unless the surface color is integrated into the work, it is wasted. Think carefully at the beginning of the drawing and work out what role the surface color can play.

colored pencil marks on colored paper

Pastel pencil on blue paper

Indicate the main shapes with the side of a gray pastel pencil. Mark the position of the sun with a white pastel pencil.

Block in the main tonal areas, moving both the light and dark pencils at the same angle, in the same way as you would when hatching.

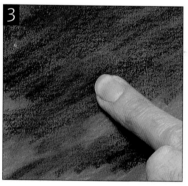

Smudge the large areas with your finger to soften the drawn lines.

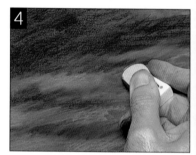

Using the tip of a kneaded eraser, lift out any areas that have been oversmudged. (This is a useful technique, but try not to rely on it; the work can easily become "muddy.")

Other Subjects For Colored Surfaces

Petals

Delicate, translucent subjects such as these lily petals need to stand out from their backgrounds. Here, the dark paper provides a wonderful contrast; although the petals have been beautifully drawn, they would have had far less impact on white paper.

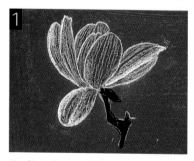

Outline the petals in white colored pencil, leaving plenty of space between the strokes so that you can build up the color later on.

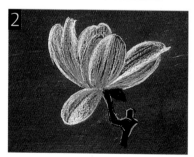

Using long pencil strokes, add pink over some of the white to provide shaping and shading.

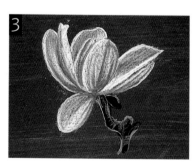

Using a little more pressure, build up the color using white over pink and pink over white—each application modifies the underlying colors. Add purple and blue to suggest texture.

Beige pastel paper

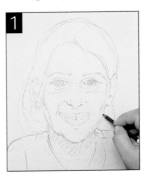

Create the sun's rays by drawing along the edge of a piece of paper or card with a white pastel pencil. Smudge the edges slightly to give them a natural look.

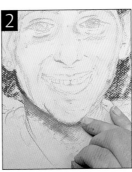

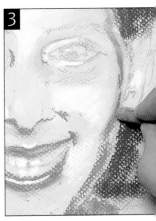

Using a gray pastel pencil on beige pastel paper, make an initial drawing to establish the basic proportions. The paper was chosen because its color is sympathetic to the color of the face.

Enhance the shapes a little more with soft pastel, blending the marks here and there with your finger. This process begins to establish the early tones.

Gradually build up the layers of color, using both the tips and sides of the pastels. Add white to create highlights.

Outline the edges of the clouds with a white pastel pencil, and add a landscape silhouette below. The dark blue surface is the perfect choice for a moody sky, while the glinting pastel strokes convey the quality of the light beautifully.

Add details to finish, but take care not to overwork the piece.

The colored paper is still visible in the finished piece. Choosing a mid-tone paper has helped to unify the piece, because the color relates to the face, the clothing, and the background.

Left
RESTING • Ron Ripley
(pastel on paper)
In this ethereal pastel study, the colored pastel paper is much in evidence. The light gray-blue surface is visible throughout the work, creating a unifying effect.

TECHNIQUE 8 • Blending and Layering Pastels

Materials

- (Tinted) pastel paper
- No. 4 flat hog's-hair brush
- Range of oil pastels
- Range of soft pastels
- Charcoal
- 4B graphite pencil
- Spray fixative
- Turpentine

Soft pastels can be blended using cloth, paper, a torchon, or your finger. It is relatively easy to blend them into textures, particularly on a pastel paper that has a good "tooth."

As soft pastels are opaque, you can put one color on top of another without the first color showing through. This is known as layering, and it allows you to put a light color on top of a dark one. This is a useful technique for depicting textural effects.

Oil pastel can be combined with soft pastel. The same blending and layering techniques apply, but oil pastels are a little harder and require firmer pressure.

Layering soft pastel with oil pastel

Using charcoal, draw your subject on tinted pastel paper. Use line only, with no shading.

Introduce sky blue soft pastels and blend the sky area with your fingers to create a smooth finish. Apply very light pressure—too much and the pastel will disappear.

Other Subjects For Blending and Layering Pastels

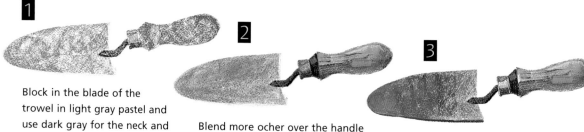

Trowel

Pastel marks often look broken because of the texture of the paper. If you want a continuous tone (on a metal object, for example), blend the marks. Layering the colors without blending them allows the first color to show through. This is used here to create the impression of rust on the blade.

Block in the blade of the trowel in light gray pastel and use dark gray for the neck and chrome ring where it attaches to the handle. Block in the wooden handle in a dark ocher.

Blend more ocher over the handle to create a smooth surface, add detail in a red-brown. Use dark brown near the chrome ring. Blend the blade with a torchon and fix the work.

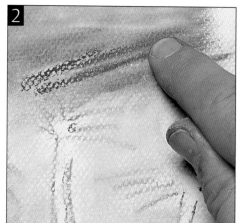

Apply terracotta on top of the light gray to suggest the rusty, textured pitting on the blade and outline the edge of the blade in dark red-brown to complete the work.

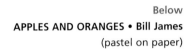

Continue drawing and blending, creating an underpainting of pale soft pastel colors. Fix the first layer of pastel with spray fixative.

As work progresses, blend less in order to show more texture. Introduce differing shades of brown, green, blue, and white oil pastels: oil pastel adheres well on top of the dry, chalky surface, producing brilliant final color accents and an interesting waxy texture.

Below
APPLES AND ORANGES • Bill James
(pastel on paper)
This still life, drawn from an unusual angle, provides a good example of blending and layering. The textures of the fruits—the pitted skin of the oranges and the apples with their many tones of red and green—are rendered in an impressionistic manner.

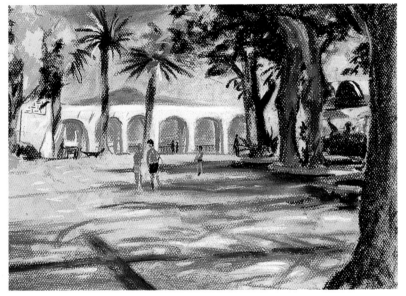

The pastel painting is now complete. Layering and blending enhance the textured areas, particularly in the trees where more oil pastel is used in the final stages.

Left
BAOB AT DINNER KEY • Bill James
(pastel on paper)
The worn surfaces of the boats and their reflections in the water were created by blending and layering pastels on the paper. The result is a tranquil, softly-colored scene transfused with light.

TECHNIQUE 8 • Blending and Layering Pastels

Blending oil pastels

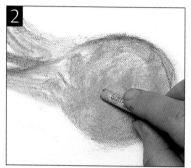

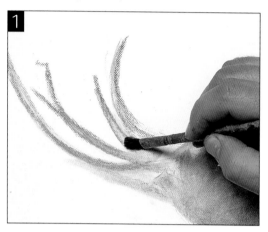

Begin by drawing an onion in oil pastel, and then smooth out the color using a no. 4 flat hog's-hair brush dipped in turpentine.

Add more color with oil pastel and smooth slightly with your finger for a concentrated effect.

crosshatched and blended
soft pastel lines

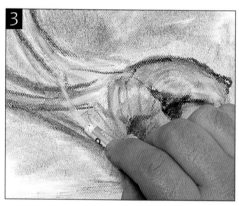

Add detailing with a dark oil pastel, and highlights with white, smoothing with your finger to modify the light color. Brush oil pastel pigment diluted with turpentine onto the background with a no. 4 flat hog's-hair brush.

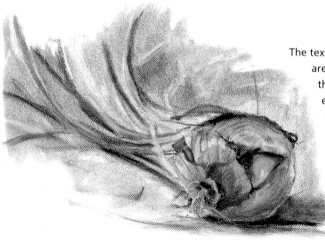

The textures of the onion are clear and precise; the broken skin is effective but subtle, because the turpentine softens the oil pastels.

spray fixative

Right
Duck at Metro Zoo • Bill James
(pastel on paper)
Here the artist has skilfully conveyed the soft, iridescent plumage of the duck and the gently rippling water, which both contain tiny areas of different colors, by blending and layering the pastels.

Shiny animal skin

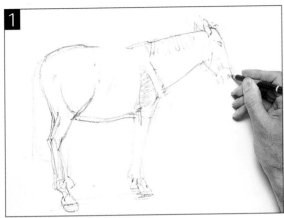

Using a 4B graphite pencil, lightly draw the outline of the horse, keeping the drawing loose and free.

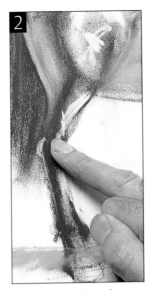

Begin to add the soft pastel colors—Burnt Sienna and Yellow Ochre, plus white for the highlights—and blend them with your finger to suggest the shiny, smooth texture of the skin.

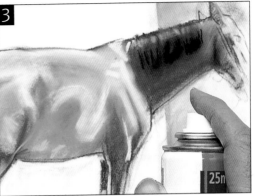

The "sheen" on the horse's skin is now evident. To prevent any loose pigment from smudging, spray the work with fixative. Complete the study by darkening the tones with Burnt Umber.

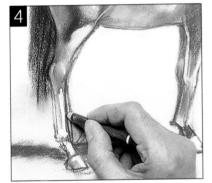

Here, the rear leg is slightly misshapen, but as the pastels are opaque, you can easily cover over the mistake.

Below

BUS TURNING IN PICCADILLY • Michael Lawes
(pastel on paper)
Here, the artist blended and layered pastel colors to create a range of surfaces and city textures. Light over dark and dark over light produce wonderful reflections on the buildings, vehicles, and roadway.

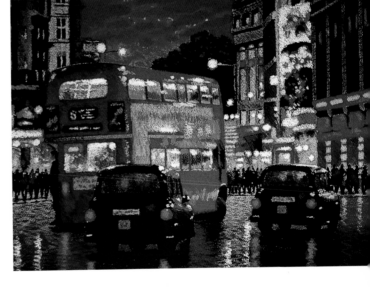

Blending soft pastel marks is the perfect technique for conveying the smooth texture of the horse's skin, the subtle gradations of tone, and the reflective highlights where the skin catches the sun.

TECHNIQUE 9 • Pen and Pencil Wash Techniques

Materials

- Watercolor paper
- Range of watercolor brushes
- Range of oil-painting brushes
- Range of water-soluble crayons
- Range of water-soluble pencils
- 3B graphite pencil
- Artist's fountain pen
- Kneaded eraser

Combining techniques can be fantastic fun, as well as a means of creating texture and detail. These pages demonstrate how you can combine the fine detail normally associated with pen-and-ink or water-soluble pencil work with the looseness and fluidity of watercolor or ink washes. These versatile techniques offer a creative way of working.

water-soluble pencil marks to which water has been added with a brush

Blending water-soluble pencil marks

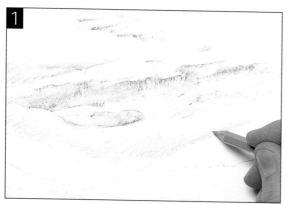

Draw into the sky with blue and gray water-soluble pencils. Dip a no. 4 watercolor brush in clean water and brush it across the pencil marks so that they blend and run slightly. Draw the distant mountains using a Raw Sienna pencil.

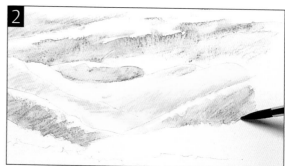

Using a Burnt Sienna pencil, draw the mountains in the middle distance and brush on water.

Other Subjects For Wash Techniques

Line on wash

Another way of producing line and wash is to paint first with very loose watercolor and then add the lines. Textures occur in two ways: wet-into-wet watercolor effects on the underpainting create a soft background, and ink lines provide sharp detail.

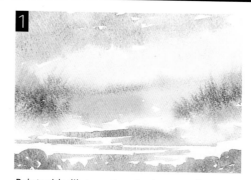

Paint with dilute watercolor in a very loose and random manner. Allow the work to dry completely: this is very important.

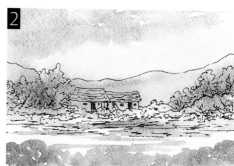

Introduce pen work on top of the dry watercolor. Try to see potential as the line work progresses—colored background shapes can become many different subjects.

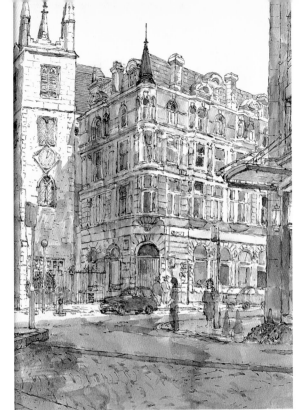

Left
SEPIA BUILDINGS • **Malcom Jackson**
(sepia line and wash)
Here, the artist has used sepia line and wash-line for the fine architectural detailing of the building's façade and wash to convey the different tones. The wash is particularly effective in the shadow areas.

The small mountain sketch is now complete. Note how the textural detail in the foreground is obtained by leaving some of the pencil marks dry.

Using a Burnt Umber pencil, draw the foreground area, again adding water with a no. 4 watercolor brush.

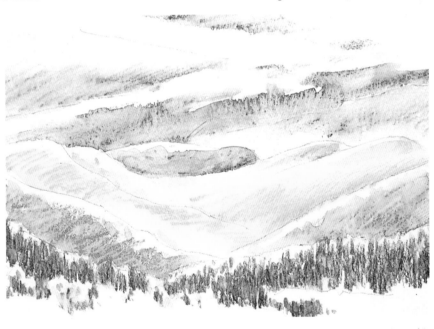

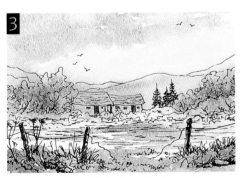

Complete the study by introducing texture and detail in the foreground.

Right
MOORINGS • **Michael Warr**
(colored pencil and watercolor wash)
This study utilizes Indigo non-water-soluble colored pencil, combined with a dilute mixture of Ultramarine and Burnt Sienna watercolor paint. Note how the pencil work is used on the sea and distant cliffs—it is also used for the gulls and this feature extends the technique into the sky.

TECHNIQUE 9 • Pen and Pencil Wash Techniques

Intensifying colors

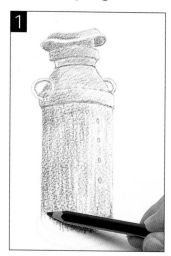

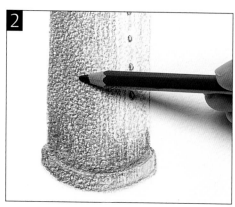

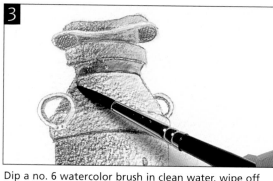

Dip a no. 6 watercolor brush in clean water, wipe off any excess, and brush across the top of the milk churn to blend the colors to a smooth sienna.

On cold-pressed or rough watercolor paper, which echoes the texture of the subject, begin the drawing using Raw Sienna, Burnt Sienna, and Burnt Umber water-soluble pencils.

Continue drawing with these colors, making sure that the pencil strokes follow the form of the subject. Note that on the main body, the pencil strokes are vertical.

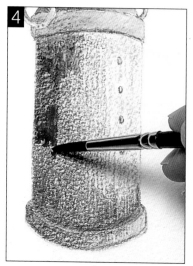

Using the same brush and water, move down onto the main body of the milk churn, brushing in the same direction as the original pencil marks.

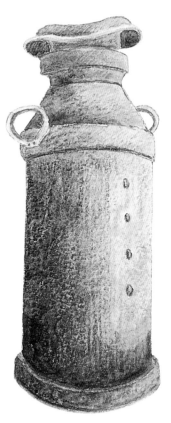

Clean the brush and continue adding water until the study is complete. The washed colors are considerably more intense than they were in their dry state.

Left

REAR VIEW OF FIGURE • Richard Bolton
(Sepia ink and wash)
The combination of Sepia ink pen and diluted Sepia ink wash have produced a good example of line and wash work. Using the same medium and the same color has created a perfectly unified picture.

Watercolor wash on ink

1

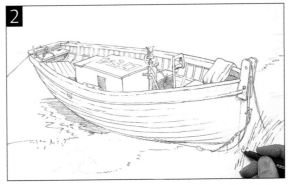

2

3

On hot-pressed (smooth) watercolor paper, lightly draw the boat in a 3B graphite pencil, then begin drawing over the pencil lines with an artist's fountain pen.

Complete the ink drawing, leave it to dry, and carefully erase any remaining pencil lines with a kneaded eraser.

Dip a no. 6 round, pointed watercolor brush in a middle tone of Payne's Gray and apply a wash around the boat. Switch to a no. 6 flat oil-painting brush and introduce foreground texture by stippling with a darker tone of gray.

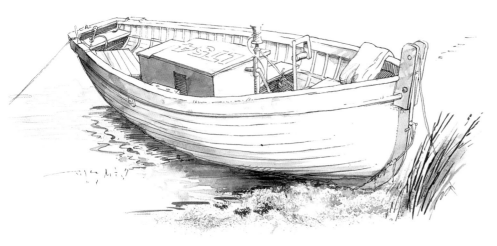

Use a soft watercolor brush and various shades of Payne's Gray on the boat to complete the monochrome line-and-wash study. The stippled texture in the foreground is enhanced by using a stiff oil-painting brush.

Blending water-soluble crayons

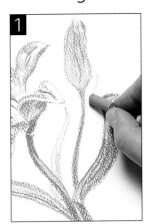

1

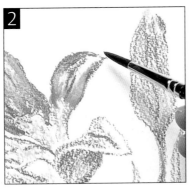

2

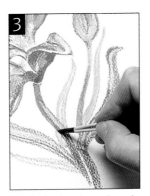

3

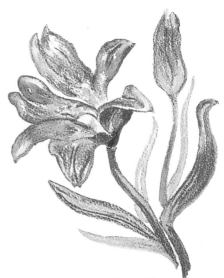

Using water-soluble crayons, draw a lily on rough watercolor paper. Use deep red and yellow for the petals, and light and deep olive greens for the stem and leaves. Apply a reasonable amount of pressure.

Dip a no. 4 round brush in water and carefully brush over the petals. Merge some yellow into deep red, but try to leave some white paper showing through here and there. Note how the color intensifies when you add water.

Wash the brush, and apply clean water over the leaves and stem. Make sure you do not add too much water, just enough to activate the color pigment.

As the waxy crayon dries, residues of pigment are left on the paper, creating an interesting broken texture that contrasts effectively with the smooth, brushed areas. The rough surface of the watercolor paper also contributes to the texture of the drawing.

Painting Mediums

Any type of paint is suitable for use in paintings portraying texture: it is the way in which it is used that determines whether or not the painting is successful. In this book, we look at watercolor, gouache, acrylic, and oil, occasionally mixing some of them together, as this can produce surprising and exciting work.

You don't, initially, need to use all the mediums mentioned. Perhaps start with one, explore its possibilities, and then move on to another. Every medium has its own natural capabilities for producing texture—and its limitations—and you need to discover these for yourself.

watercolor paints

watercolor pans

gouache

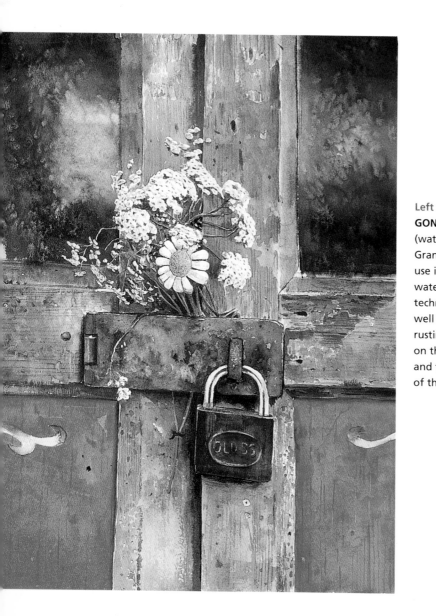

Left
GONE OUT • Richard Bolton
(watercolor on paper)
Granulation is put to good use in this charming watercolor painting. The technique works particularly well in three areas—the rusting stable lock, the lichen on the wooden door frame, and the blue areas at the top of the painting.

brushes suitable for watercolor

Left
LIONESS • Paul Dyson
(watercolor and gouache
on paper)
The highlights in this painting
are skilfully painted in opaque
white gouache over
translucent watercolor. Note
how the fine brushwork allows
the light to trickle over the
face and onto the paws,
adding drama to this superbly
detailed animal portrait.

But whatever type of paint you choose, there are basically two factors to consider: how best to exploit the natural textural qualities of a given paint and how to use the brush, or other painting tool, to convey textural effects. Often both of these factors come into play. Practice the exercises in this book: they'll give you a wonderful introduction to painting textures and, once you've built up your confidence and skill levels sufficiently, you can start to develop your own ideas and approaches.

acrylic paint jars

bristle brushes
suitable for oils
and acrylics

oil paints

acrylic paints

Right
TEMPTING FRUIT • Brian Gorst
(oil on canvas)
To achieve the glinting highlights
and details on the strawberries,
the artist scratched into wet oil
paint with the pointed handle of
an oil painting brush, exposing
very light color underneath.

TECHNIQUE 10 • Blending

Materials

- Canvas board
- Heavy, cold-pressed white watercolor paper
- Range of oil and watercolor brushes
- Range of oil paints
- Range of gouache paints
- 2B pencil
- Gum arabic

gouache paint blended with a watercolor brush

Blending is a frequently-used technique. It is particularly useful for shading and conveying light, both natural and artificial. Blending is also a good way to describe a smooth texture, and it is often combined with highlighting (see pages 66–67).

It is relatively easy to blend dilute watercolor, but oils, acrylic, and gouache require more brushwork. Whatever the medium, the biggest risk with blending is that you overdo it: muddy colors can easily result. To avoid this, make sure you do not mix too many colors at any one time.

Blending oil paints

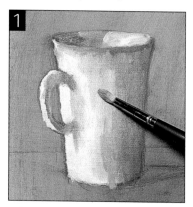

Paint a mug on a neutral surface (ground) using a no. 4 round hog's-hair brush and thick, undiluted oil paint.

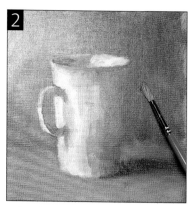

Paint the background using a somber green oil paint and a medium-sized round hog's-hair brush. Keep it simple; you need only suggest the surface, not paint it in detail.

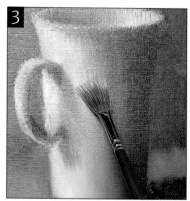

Blend the color on the mug with a blending or fan brush, smoothing out the paint with long strokes. This creates the smooth texture of the porcelain surface.

Other Subjects For Blending

Blending watercolor

A good way to practice blending watercolor is to paint skies. Work wet into wet, and simply allow the colors to blend together. It is important to strive for simplicity!

Using pale, watery paint, apply Cerulean Blue, Ultramarine, Alizarin Crimson, and Cadmium Yellow in horizontal strips and let them blend wet into wet. While the paint is damp, paint in the shape of the sun with Cadmium Yellow.

When the paint is dry, apply a weak mixture of Ultramarine and Alizarin Crimson to the background, using a small, natural sponge. Leave to dry.

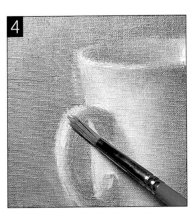

Create contrast in the tones by using lighter and darker colors, and apply highlights with thick paint and a medium-sized round hog's-hair brush. Do not worry about going over the edges.

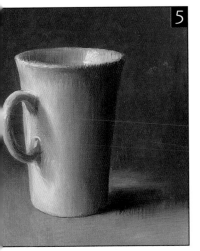

Finally, use a blending or fan brush to smooth and blend the background colors. If necessary, use the same technique to define the edges of the mug.

Blending gouache

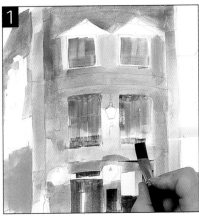

Using a 2B pencil, lightly sketch the subject. Using a no. 12 flat soft brush, wash dilute gouache over the drawing to establish general areas of color, leaving white paper where the glow from artificial light will appear.

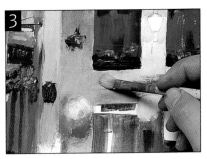

Where warm and cool colors appear next to one another, blend them with a stiff brush or your finger. Warm and cool colors seen together are ideal for night-time subjects.

Add gum arabic to thicker gouache to improve the paint's fluidity and luminosity. Apply the paint with a no. 4 flat hog's-hair brush to cover the underpainting and suggest texture. White gouache provides the source of light.

Complete the painting by including details on windows, doors, and lamps. Gouache blends well because it is creamy and opaque. It is the ideal medium for blending the artificial light into its surroundings in this painting.

Using a larger sponge, apply stronger mixes of Ultramarine and Alizarin Crimson to suggest trees and a foreground. Paint the trunks and branches with a small pointed brush. This provides a great contrast to the blended sky.

Top right opposite page
UNINSURABLE • Barbara Dixon Drewa
(oil on canvas)
A lot of time was spent blending the oil paints to create the smooth textures in this painting. The wrapping paper and adhesive parcel tape areas are a good example of blending subtle colors.

Right ANTICIPATION • Lydia Martin (oil on panel)
The tones on these decorations range from dark to "highlight," and the paints had to be carefully blended. The colors are yellow under red, light pink, blue under blue, and yellow under green. The artist also blended the color of the box.

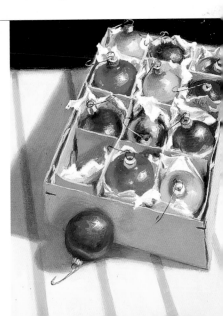

TECHNIQUE 11 • Granulating Washes

Materials

- Cold-pressed watercolor paper
- Range of watercolor brushes
- Range of watercolor paints

Granulation is predominantly a watercolor effect, but you can obtain similar results with diluted gouache or acrylic. Granulation takes place when pigments separate on textured watercolor paper. The heavier part settles in the indents; the lighter part on the bumps. This paint–paper interaction can be used to great advantage when textures are required.

Granulation for weathered skin

Lightly draw the subject on roughly textured watercolor paper, and begin painting with a no. 6 round sable brush and a dilute mix of Raw Sienna and Alizarin Crimson. Remember to leave some highlights. Allow to dry.

Apply a wash of Alizarin Crimson for warm tones of older, roughened skin. Allow the pigment to settle into the indentations on the paper.

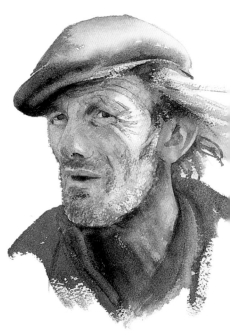

Use mixes of Prussian Blue, Alizarin Crimson, and Burnt Umber on the face; Raw Umber and Cerulean Blue for the cap; and Ultramarine mixed with Burnt Sienna for the jacket. Granulation conveys the weather-beaten, unshaven skin textures perfectly.

COLOR MIXES THAT GRANULATE

 Ultramarine & Alizarin Crimson

 Ultramarine & Cadmium Yellow Pale

 Ultramarine & Burnt Sienna

 Ultramarine & Light Red

 Ultramarine & Cerulean Blue

 Lamp Black & Raw Sienna

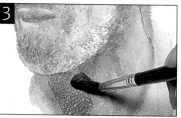

While the Alizarin Crimson is still damp, add Cerulean Blue for the beard and shadows on the neck.

Other Subjects For Granulating Washes

Wall

Here, granulation is exploited to create texture in a painting of a rendered wall. Adding a window places the wall in context and introduces some detail.

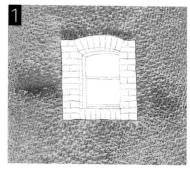

Apply a wash of Ultramarine and Burnt Sienna to the area around the window. The two colors granulate, creating a texture.

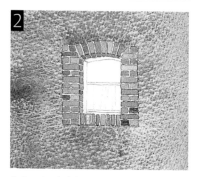

Paint the bricks around the window frame in a mix of Raw Sienna, Alizarin Crimson, and Ultramarine.

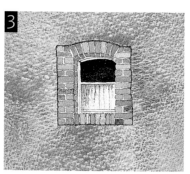

Paint a curtain on the lower half of the window in Payne's Gray and add a dark version of this color to the area above.

Tree in winter

1

Using a no. 8 watercolor brush, paint the top half of the sky with a very pale mixture of Cerulean Blue and Ultramarine, and the bottom half in Burnt Sienna. Leave to dry.

2

Mix together Ultramarine and Burnt Sienna for the tree trunk and branches. The two colors granulate if they are not overbrushed, producing a bark-like texture. Add smaller branches with a no. 2 round pointed watercolor brush.

3

Brush clean water over the snow area, and paint the shadows on the snow under the tree in mixtures of Ultramarine and Alizarin Crimson. The colors granulate and blend wet into wet.

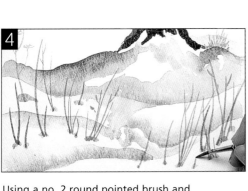

4

Using a no. 2 round pointed brush and alternating between Ultramarine and Burnt Sienna, paint some vegetation in the foreground. This produces a pleasant balance of warm and cool colors.

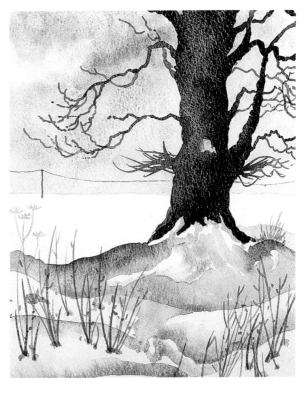

Granulating washes have been used to great effect in this painting, suggesting both the bark of the tree and the crystal-like texture of the snow.

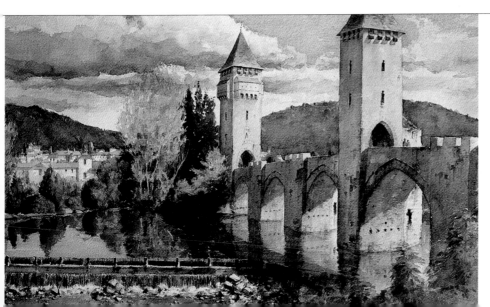

Left

PONT VALENTRÉ II • Jack Lestrade
(watercolor on paper)
Look at the shadows on the granite bridge and tower in this painting: the use of granulating colors has helped to depict the texture of the stone in a convincing manner.

TECHNIQUE 12 • Wet into Wet

Materials

- Cold-pressed watercolor paper
- Range of watercolor brushes
- Range of watercolor paints
- White gouache
- Range of water-soluble pencils
- India ink
- Sandpaper

Many effects and textures can be obtained by applying wet paint on top of wet paint. Depending on the medium you choose, the results vary enormously: wet-into-wet watercolor, for example, looks completely different from thick wet-into-wet oil paint. Mixed mediums lend themselves to this technique and offer you the chance to experiment. You will discover many different textures as a result.

Wet-into-wet mixed mediums

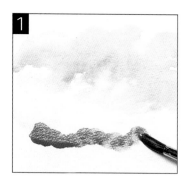

Paint a sky, using a mixture of Ultramarine and Burnt Sienna watercolor paints. Paint some initial foreground color with Cadmium Yellow mixed with Ultramarine.

Using a no. 3 small pointed brush, quickly tease out some stems from the wet paint.

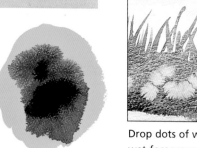

watercolor and gouache colors dropped onto a surface, wet into wet

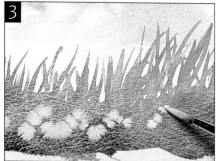

Drop dots of white gouache onto the still-wet foreground wash and allow them to disperse a little.

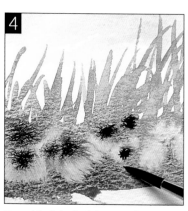

Drop black India ink onto the wet gouache. It will spread and begin to create a texture in the foreground. Allow the painting to dry.

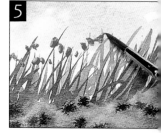

Using a fine brush and Hooker's Dark Green watercolor paint, strengthen some of the stems, and add bright Cadmium Red blooms to suggest poppies. This is a simple way of providing foreground detail.

Other Subjects For Wet into Wet

Wooden Post

Interesting wet-into-wet effects can be obtained by dropping moist gouache onto wet watercolor. The gouache spreads slightly as it comes into contact with the wet watercolor, creating interesting textural contrasts of opaque (gouache) and translucent (watercolor) mediums.

Paint the shape of a wooden post with watercolor; Ultramarine mixed with Burnt Sienna will granulate and form a good texture.

While the shape is wet, add a darker tint of the mixture to the left side of the post and drop in some white, moist gouache. This spreads, suggesting lichen-like shapes.

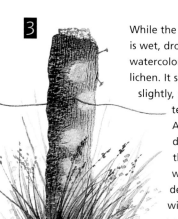

While the gouache is wet, drop yellow watercolor onto the lichen. It spreads slightly, producing texture. Allow to dry. Finish the study with the details: wire, nails, and wood grain.

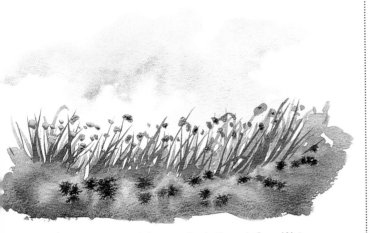

Finally, paint the centers of the poppies in Payne's Gray. Wet-into-wet blending is an excellent way of producing textures in landscape paintings. The viewer's eye can move over these areas and into the rest of the picture.

Run backs

Quickly paint a sky and an area below it with a mixture of Ultramarine and Burnt Sienna watercolor. While the paint is still wet, drop clear water onto the sky. This creates "run backs" as the water tries to "escape" into the surrounding, not-so-damp areas.

When the painting is dry, add trunks and branches with a no. 3 fine brush and a mixture of Ultramarine and Burnt Sienna on the run-back areas.

Using a no. 3 small pointed brush, add some vegetation in the foreground. The edges formed by the run backs create wonderful, ragged textural qualities.

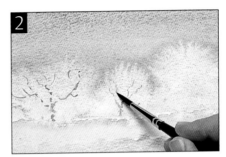

Above
WORK COMPANIONS •
Dana Brown
(watercolor on paper)
The carefully-drawn shapes in this industrial subject were painted using wet-into-wet technique, allowing tones to merge on the paper and create a smooth surface in which no brush marks can be seen.

Right
COOL, MISTY MORNING •
Michael Warr
(watercolor on paper)
The misty area and foreground were painted wet into wet. These areas are offset by the use of strong, bold, but undetailed shapes. There is a balance of techniques, each helping the other and, thereby, creating overall unity.

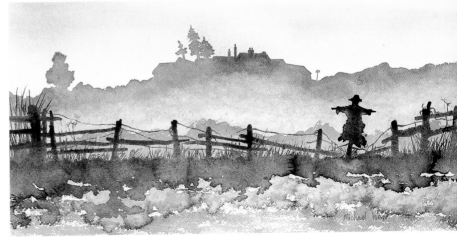

TECHNIQUE 13 • Dry Brush

Materials

- Watercolor paper
- Range of watercolor brushes
- HB pencil
- Range of watercolor paints
- Two jars of clean water: one for mixing and diluting your paint and one for rinsing your brushes

This is an excellent technique for suggesting rough or speckled textures. There is one important technical factor to bear in mind— the paint must be dilute, not dry. Ensure that there is not too much paint on the brush or you'll find that the indentations on the textured watercolor paper will fill with color. The color should be stroked onto the paper so that the paint sits only on the raised parts of the paper.

The loading of paint on the brush is critical in dry-brush work. Use a spare piece of watercolor paper to blot excess paint from your brush. Absorbent tissue takes off too much paint.

Brickwork

Draw the brick shapes with a light pencil line, then apply a wash of Raw Sienna with a medium-sized brush and allow to dry.

Use a watercolor brush with splayed bristles to apply Burnt Sienna. Stroke the color gently onto the paper. Allow to dry completely.

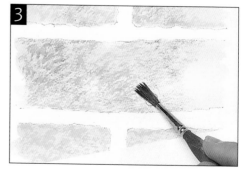

When the underlying paint is absolutely dry, again apply mixtures of Alizarin Crimson and Burnt Sienna. The need for dryness cannot be overemphasized; if it is not dry, damp paint will pick up.

Other Subjects For Dry Brush

Moss

The dry-brush technique is also suitable for various plant textures. The texture created by the tiny spore heads of the moss lends itself superbly to depiction in this way.

Apply a wash of Raw Sienna to the basic shapes. As this dries, feed Olive Green into the base of each shape and allow to dry.

Drybrush various mixtures of Payne's Gray and Cadmium Yellow over the wash until the desired effect is achieved.

Finally, add a little Burnt Sienna in the form of dots, to create the moss-like appearance of the shapes.

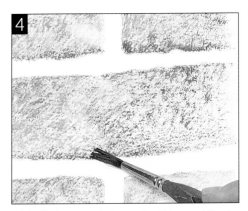

Add a little neutral tint to the Crimson Alizarin to create the color on the over-baked bricks, making sure that the brush bristles are splayed. This mixture is also used to suggest shading under each brick.

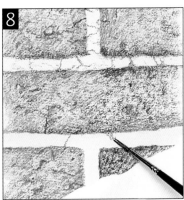

Apply Burnt Sienna with a smaller brush to strengthen and define the edges.

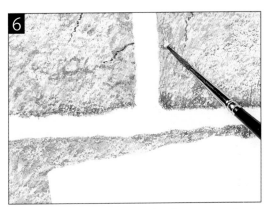

Examine the created textures for the opportunity to add details such as holes, raised areas, and cracks on the surface of the bricks. These are created using a round pointed brush in its normal shape, and dark dilute paint.

Below
EARLY WINTER • Lydia Martin (oil on panel)
Here, the dry-brush technique was used with oil paint to create the contrasts between light and dark areas in the foreground grasses and also the dry, brittle texture of the bales of straw.

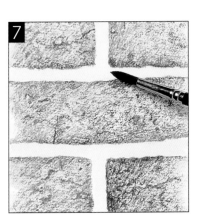

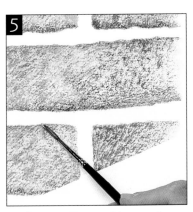

Apply a wash of Raw Sienna mixed with a little Payne's Gray to the area of mortar.

Complete the mortar by drybrushing with Payne's Gray, then hint at a few cracks for the final effect.

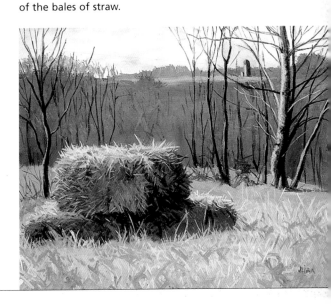

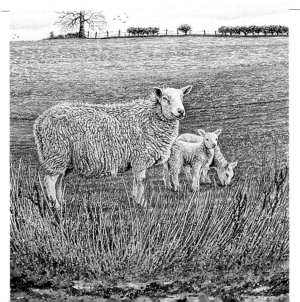

Left
FAMILY • Michael Warr (dry-brush watercolor on paper)
Apart from the sky, the whole of this painting was produced using the dry-brush technique. The brittleness of early spring is evident in the vegetation, and the technique perfectly captures the woolly coats of the ewe and lambs.

Rusty Horseshoe

Here we can see the stages of dry-brush watercolor painting all in one image. The far right side of the painting is complete, while the rest enables us to see applied color from one layer, through to two, three, even four layers.

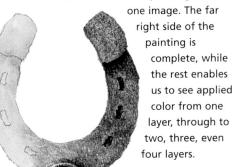

TECHNIQUE 14 • Scumbling

Materials

- Heavy-weight watercolor paper
- Range of hog's-hair brushes
- Range of watercolor brushes
- Medium-sized decorator's brush
- Range of acrylic paints
- Range of gouache paints

Scumbling is a technique that can be employed with any paint medium; it means working over a dry area with a scrubbing motion so that the paint is applied in many directions. The secret is not to cover an area too quickly; a small amount of paint on the brush at any given time is the order of the day.

light, textural qualities are easily achieved with scumbling

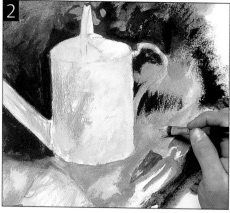

Apply a thin layer of acrylic paint to the watering can, then scumble more colors into the background, applying dark over light with a no. 8 flat hog's-hair brush. Let it dry. Scumble further layers with dryer paint, including light red-brown over part of the watering can.

Scumbling with acrylics

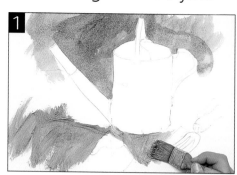

1 Thin some acrylic paint with water and use a medium-sized decorator's brush to scumble some background around the drawn watering can, flowerpot, and small garden fork. Leave to dry.

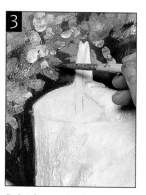

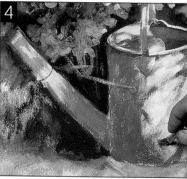

3 Paint leaves in the background, using thicker paint and a no. 3 flat hog's-hair brush.

4 Scumble a dark red-brown color over part of the watering can. This gives an interesting textural effect, like rust.

Other Subjects For Scumbling

Bloom on plums

Some fruits have a "bloom" on their surface—a hazy coat that is invisible in certain lights. To render it convincingly, the individual brushstrokes must not be seen. With acrylic and oil paints, scumbling is the perfect solution.

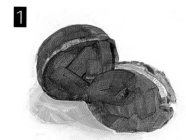

1 Paint the plums' shape and color in mixtures of Alizarin Crimson, Yellow Ochre, Phthalo Blue, and purple acrylic paint. The background is a mixture of Payne's Gray and white.

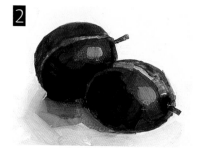

2 When dry, add more of the same colors to the plums, creating another layer to make the subjects more solid. Include more white on the background. Leave to dry.

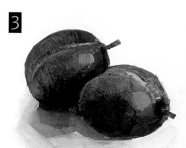

3 Scumble Phthalo Blue mixed with white onto the upper surface of the plums to create the "bloom." Remove any excess paint with a paper towel.

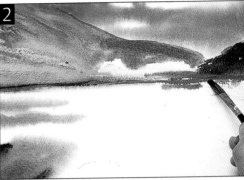

Scumble dark color around the pot and fork to make them stand out from the background. Add some detail to them and the painting is complete.

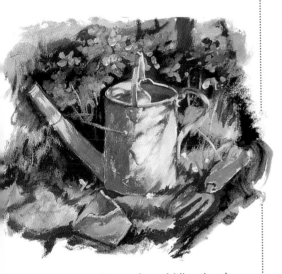

The rough, multidirectional brushwork and successive layers of paint capture the peeling, crumbling textures of the subjects perfectly.

Scumbling with gouache

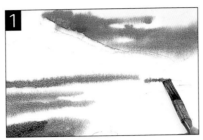

Loosely draw the mountains and lake with a medium-sized watercolor brush, wet the paper, and begin painting the sky and water areas with strong-colored mixes of gouache.

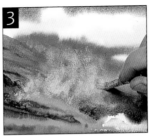

When the painting is dry, using a hog's-hair brush and reasonably thick paint, scumble a light color over the mountains to depict low, drifting clouds.

Scumbling has contributed to the textural contrasts within this painting: the solidity of the heavy, thickly painted mountains is balanced by the scumbled clouds, which look very ethereal and wispy in nature.

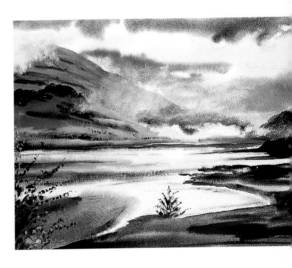

While the paper is still damp, paint the mountains with fairly thick gouache: working wet into wet facilitates blending. The colors are dark, but will be scumbled back later. Leave an area of white paper on the right for low-lying cloud. Paint the foreground using a dark color and large brush. Note how this area contrasts with the light, unpainted area of water. Paint the far side of the lake wet into wet.

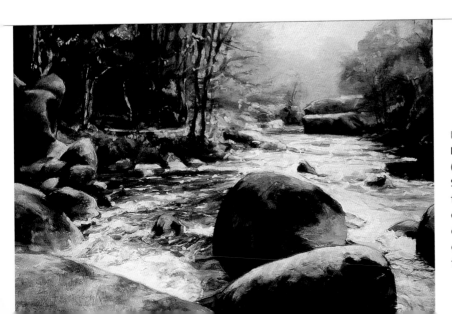

Left
BEAR HUELGOAT • Bob Brandt
(oil on canvas)
Scumbling paint over the foreground rocks, which are covered in mosses and lichens, has created a lovely, soft texture that contrasts well with the solid, hard textures of the stone.

TECHNIQUE 15 • Sgraffito

Materials

- Gesso-coated board
- Heavy-weight watercolor paper
- Range of (watercolor) brushes
- Medium-sized decorator's brush
- Range of acrylic paints
- Craft knife
- Natural sponge

Scratching into paint or the painting surface is known as sgraffito. Many tools can be used for this purpose, including the handle of a paintbrush, craft knife, or a razor blade. Sometimes scratching into one layer of paint to expose an underlying layer is sufficient, but at other times you may need to scratch back as far as the surface or even into the surface. Texture always emerges as a result of this process.

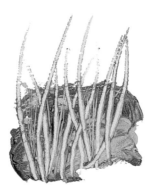

shapes made by lifting out wet watercolor with a palette knife

Scratching into acrylic on gesso

Paint a loose version of a rope and frayed ends onto gesso-coated board in Burnt Umber acrylic paint. Sponge paint over the background. The effect requires at least two layers of paint.

Add details to the rope with a fine pointed brush and Raw Sienna. The paint needs to be reasonably dilute at this stage.

Continue adding detail, depicting the weave of the rope by painting individual strands. Make sure that the brush has a good point; sharp lines are essential to make the "weave" look convincing. Leave to dry.

Using a sharp craft knife, scratch right back through the paint into the white gesso surface. This creates the effect of fine wisps of rope.

Other Subjects For Sgraffito

Fish

The sgrafitto technique works well with any medium, and watercolor is no exception. Here, a painting knife is used to capture the texture and markings of a fish painted using only two colors.

Using a 2B graphite pencil, draw the shape of a fish. Lightly indicate the eye, mouth, and fins. Using a no. 4 round pointed brush and Ultramarine mixed with a little Burnt Sienna, paint the top of the fish.

Allow this to dry for a few seconds, then lift out markings with a palette knife. Paint a dilute version of the first wash over the lower body, wait a few seconds, and again lift off markings. Paint the gills and the area around the eye in Burnt Sienna.

Paint the fin in the color mixture used in Step 1 and lift off markings. Then mix in extra Burnt Sienna and do the same to the tail. The eye needs a darker mixture of these colors. Fill in the background.

Using longer strokes of the craft knife, scratch the frayed ends of the rope.

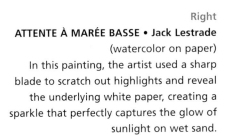

Complete the sgraffito work, and tint some of the white strands with dilute Raw Sienna. The lines created by sgraffito convey the extremely fine sisal strands and are much finer than could be achieved with a brush.

Scratching into acrylic on paper

Using a decorator's brush and dark acrylic paints, paint the dark corner of a hedgerow. The darkness is important, as this will help the cobweb to stand out. Allow the painting to dry thoroughly.

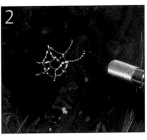

Begin scratching the shape of the cobweb with a sharp craft knife. (Make sure that the blade is new.) Follow the sketch, as this gives you a guide to the overall shape.

It is a good idea to keep this sketch handy, as it will be extremely useful when the sgrafitto technique begins.

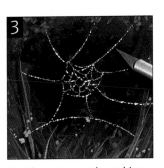

Continue to scratch, making sure that there are outer strands attached to some vegetation. Note how small tears in the paper produce a dew-like sparkle, adding life to the cobweb.

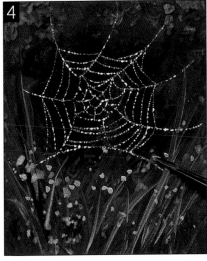

Complete the web and, with a no. 3 fine pointed brush and pink acrylic paint, add flowers in the foreground. The use of sgraffito here conveys delicacy and sparkle.

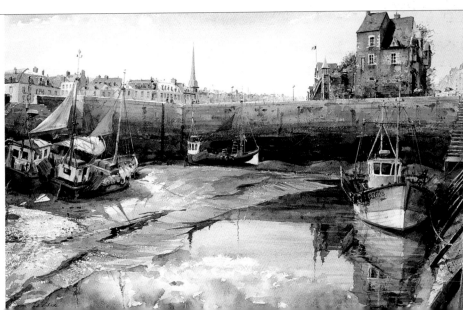

Right
ATTENTE À MARÉE BASSE • Jack Lestrade
(watercolor on paper)
In this painting, the artist used a sharp blade to scratch out highlights and reveal the underlying white paper, creating a sparkle that perfectly captures the glow of sunlight on wet sand.

TECHNIQUE 16 • Textured Detail Work

Materials

- Cold-pressed watercolor paper
- Range of watercolor brushes
- 2B pencil
- Range of watercolor paints
- Range of gouache paints

Painting detail and texture requires practice and patience. Because accuracy is important when you're working on a small scale, the best thing to do is to slow down. Get used to using small brushes, and spend more time mixing colors.

Close observation is also essential, and you should spend at least as much time looking at your subject as you do actually putting brush to paper. Keep an eye out for textured subjects and record your ideas in a sketchbook for later use.

Watercolor Details

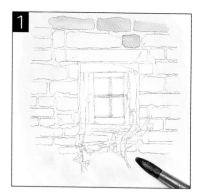

1 Draw the shapes of the window and surrounding stonework with a 2B pencil. Make a thin, watery mixture of Raw Sienna and Burnt Sienna watercolor paint and apply it over the stonework, but not the window. Leave to dry.

2 Paint individual stones with a small watercolor brush and mixtures of stronger Raw Sienna, Burnt Sienna, and Payne's Gray. Colors for the bricks are mixtures of Alizarin Crimson and Raw Sienna. Continue until the stonework is complete, and then allow to dry.

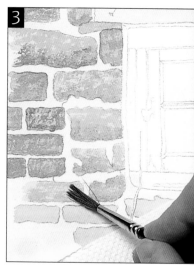

3 Mix slightly stronger versions of colors already suggested, and drybrush them over individual stones (see pages 54–55). Rest your hand on paper to keep the painting clean.

Other Subjects For Textured Detailed Work

Leaf

This simple subject is great for textural studies. The colors of the leaf merge into each other; painting them wet into wet allows them to spread naturally. For sharper detail, such as the veins and mold spots, painting wet onto dry lets you control the paint very precisely.

1 Using a no. 5 round pointed brush and Prussian Blue and Sap Green watercolors, paint shadows to outline the leaf. Leave to dry.

2 Wash a mixture of Sap Green and Cadmium Red over the leaf. While this is still damp, add Yellow Ochre and Prussian Blue. Leave to dry.

3 Add details such as the veins and stem in Sap Green, Cadmium Red, and Yellow Ochre. Use Burnt Sienna for the mold spots and leaf edges.

Gouache details

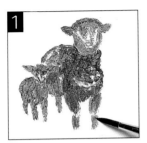

1 Draw the sheep and lamb with a 2B pencil and paint the complete shapes with a small brush and Burnt Umber gouache. Allow to dry.

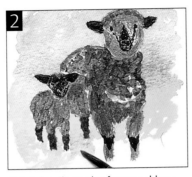

2 Paint details on the faces and legs, using Payne's Gray gouache. Allow to dry. Paint a background wash using a larger brush, pale blue and Burnt Sienna for the sky, and a yellow-green for the field.

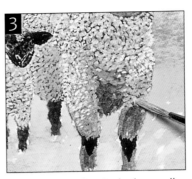

3 With a dry brush, stipple the woolly coats. Use white tinted with Raw Sienna for the lighter parts and white tinted with Payne's Gray for shaded areas. Allow small glimpses of the dark brown underpainting.

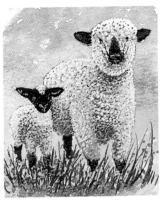

Add finishing touches to the faces with Payne's Gray. Allow the dark underpaint to play a part in producing "lines" in the wool—this results in natural-looking detail and texture.

4 Paint the details of the window and mortar joints with a no. 2 round pointed brush and varying dilutions of Payne's Gray. Note that there is a windowpane missing, creating a very dark area.

5 Paint the ivy in Olive Green, and add a cobweb in the window space with white gouache.

The finished picture shows an array of details, using a number of techniques.

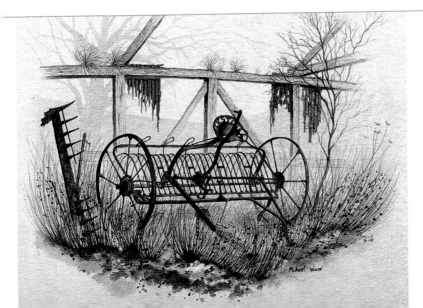

Left

FORGOTTEN CORNER • Michael Warr

(oil on canvas)

Abandoned farm implements make wonderful subjects for small-scale studies. Rust, the remains of the building, the corroding corrugated tin roof, and spiky foreground grasses provide a wealth of small details and textures. Note how the wet-into-wet effect in the foreground creates more textural effects.

TECHNIQUE 17 • Colored Surfaces

Materials

- Colored paper
- Heavy, cold-pressed watercolor paper colored with a mixture of Ultramarine, Alizarin Crimson, and a little Burnt Sienna acrylic paint
- Range of round pointed brushes
- No. 3 watercolor brush
- Range of acrylic paints
- Range of gouache paints
- White water-soluble pencil

Allowing the surface color to play a part in a painting can be very effective: leaving small areas of the surface showing through the paint provides interesting textural effects.

For gouache and acrylic paints, you can buy colored papers or make your own by coating a piece of heavy watercolor paper with acrylic color. Use a 1-inch (2.5-cm) flat wash brush to apply the color (leaving the brush marks to add texture, if you wish), and leave to dry for up to two hours.

It is easy to color white oil paint surfaces with acrylic or oil paint. A translucent medium, such as watercolor, can be used on a lightly tinted surface but not a heavily colored one.

On painted background

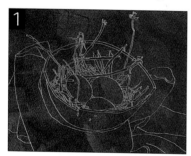

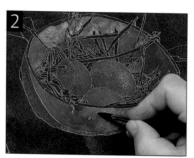

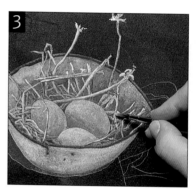

Using a white water-soluble pencil on dark paper, draw the outline of a bowl of eggs sitting on a piece of burlap. The lines show very clearly on the dark paper and, being water-soluble, will disappear when the paint is applied.

Using a no. 4 round pointed brush and dilute white acrylic paint, begin painting the bowl. Paint the rim with a mixture of Ultramarine and a little white. Paint the eggs with a dilute mixture of Ultramarine and Raw Sienna: the paper color shows through, tinting the egg color. Paint rust holes in Burnt Sienna.

Repaint the bowl and the eggs, using the same mixtures as in Stage two. Paint the straw with a no. 4 round pointed brush, using first a mixture of Raw Sienna and white, and then a mixture of Burnt Sienna and white. The background color shows through, affecting the egg and straw colors.

Other Subjects For Colored Surfaces

Profile

The subject of this painting has a relatively dark complexion. The colored surface helps to hold the whole image together much more effectively than white board or canvas ever could.

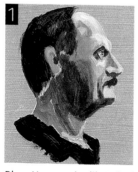

Tint white card with a mixture of black and white acrylic paint. Leave to dry. Draw the head with a 3B pencil and block in with Prussian Blue. Use purple diluted with acrylic medium for the hair. Use Flesh Tint, Cadmium Red, Purple, Burnt Sienna, and Burnt Umber for the face. The shirt is a mixture of Emerald Green and Prussian Blue.

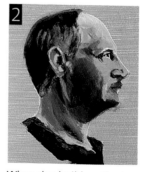

When dry, build up the tones with more layers of the same colors, using white for the highlights. Leave to dry.

Using a no. 8 hog's-hair brush, scumble the same colors as before over the face and smudge them with your finger to suggest texture. To complete the painting, add Cerulean Blue mixed with white to the forehead and parts of the graying hair.

Gouache on a black background

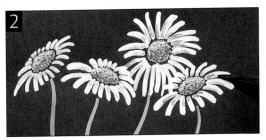

Using a no. 4 round pointed brush and a dilute mixture of Raw Sienna and white, paint the horizontal and then the vertical weave of the burlap. Vary the dilution to create color variety. Note how the paper color suggests spaces in the weave.

With a no. 3 round watercolor brush, paint daisy heads on black sugar paper, using white and Yellow Ochre for the flower centers and white gouache for the petals.

Paint the stems in a mixture of Ultramarine and Cadmium Yellow. Make a very dilute mixture of Ultramarine and Burnt Sienna, and use it to indicate shading on the petals, allowing the white to "bleed" through.

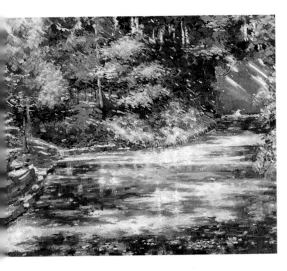

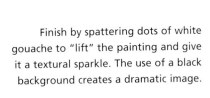

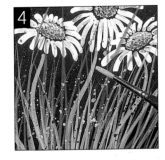

Paint grasses among the flower stems in different shades of green. Try adding Burnt Sienna to the green already on the stems; this will create variation.

Spatter dots of green and yellow randomly to convey life and texture (see pages 70–71).

Complete the weave work, then add shading to the burlap with dilute mixtures of Burnt Sienna and Ultramarine, and Raw Sienna and white. With a no. 2 round pointed brush and a mixture of Raw Sienna and white, paint the loose fibers and stitches of the burlap.

Finish by spattering dots of white gouache to "lift" the painting and give it a textural sparkle. The use of a black background creates a dramatic image.

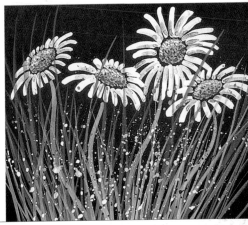

Left

PETRA CABOT'S POND and CATSKILL MORNING • Mary Anna Goetz

(oil on canvas)

Both of these paintings use a technique known as grisaille—that is, toning a surface by painting it with dilute color. In oil painting, you need to use turpentine to dilute the paint. The advantage of using dilute color is that it is transparent. The canvas glows through, whereas an opaque surface color could deaden colors applied on top of it. Allowing the surface color to show through in places also gives a sense of unity to the paintings.

TECHNIQUE 18 • Knife Painting

Materials

- Canvas board
- Cold-pressed watercolor paper
- Range of oil painting brushes
- No. 16 watercolor brush
- Range of oil paints
- Range of watercolor paints
- Palette knives
- Turpentine

knife painting is an excellent way of making textures really come to life

You can use a palette knife—also known as a painting knife—to gain immediate texture when making an acrylic or oil painting. It is relatively quick and easy to produce acceptable results, and the finished work is likely to convey a spontaneous rather than a detailed effect.

You can use palette knives both to remove and to apply paint. Try, for instance, scratching into thick, wet oil paint in order to obtain detail and texture; or see the great effects you can achieve by lifting off wet watercolor.

Knife painting with oils

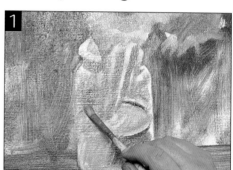

Start the underpainting using dilute oil paint and a no. 6 flat hog's-hair brush. Establish all of the areas with dilute color. This provides a plan on which to work.

Using a trowel-shaped palette knife, thickly lay on orange and brown oil paint, working out from the flower centers. The paint changes from flat to textured when the knife is pulled away from the painting.

Using a longer trowel-shaped knife, add highlights on the jar and stems. It is important to have a few sizes of palette knives, as they enable you to make strokes of differing lengths.

Still using the longer knife, paint the background. Thick paint is necessary in order to produce a painting with overall unity.

Other Subjects For Knife Painting

Wine glass

Using a painting knife allows you to make broad strokes that give an image spontaneity. One of the benefits of acrylic paint is that it is very opaque; if you make a mistake it is easy to paint over it and cover it up.

Establish the shape of the glass and its contents using large and small trowel-shaped painting knives and Alizarin Crimson and Payne's Gray acrylic paints. Scrape off any excess paint.

Rework, adding more detail with the small knife. Gradually build up a pattern of layers and reflections. Remember that you can scrape off paint if you apply it too thickly or in the wrong place.

Add details using the point of the small knife and create lines with the edge. Use the large painting knife and white acrylic paint to work the background.

Establish the final details with a no. 3 sable brush and slightly thinner paint, diluted with turpentine so that it flows more easily.

The finished painting has color, impact, and a range of textures. The speed of knife painting also produces a charming spontaneity.

Reverse knife painting

Apply loose watercolor washes, using Cerulean Blue, Ultramarine, and Burnt Sienna. Leave for approximately 30 seconds.

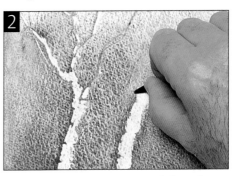

Using the blade of a small trowel-shaped palette knife, and working upward, lift off paint leaving the negative shapes of the tree trunks. Apply reasonable pressure; otherwise, the technique will not work.

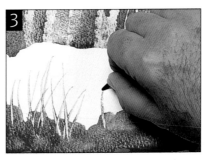

Paint a small foreground wash in the same color as the sky. Lift out some vegetation using the tip of the palette knife.

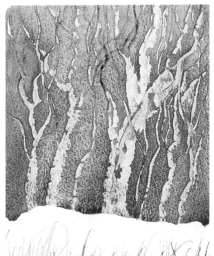

The reverse knife painting is complete. Note the interesting, natural textures created by a very simple process.

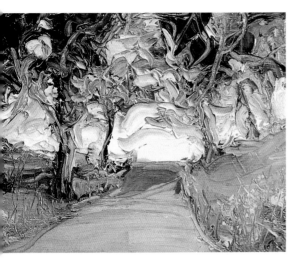

Left
TOP OF THE WOOD • Bob Brandt
(oil on canvas panel)
By using thick oil paint and applying it in swirling, vigorous strokes of the painting knife, the artist created texture in the trees and foreground. This painting has tremendous energy.

Right
A SPREAD OF POPPIES • Bob Brandt
(oil on canvas)
The artist used a knife to apply thick oil paint and create texture. With the knife tip, he then scraped off thin lines of paint to suggest corn.

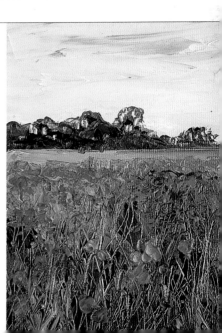

TECHNIQUE 19 • Highlighting

Materials

- Dark-colored canvas board
- Watercolor paper
- Range of oil painting brushes
- Range of watercolor brushes
- Range of oil paints
- Range of gouache paints
- 2B pencil

You can add highlights to your work in a number of ways. With opaque media, because it is possible to paint light over dark, you may add highlights at any time. You need a different approach with watercolor. In its translucent form, you cannot normally add highlights; you create these by carefully retaining the white of the paper, or by lifting off color in the final stages of the painting. You can produce very effective highlights using resists, in the form of masking fluid or wax.

Alla prima painting

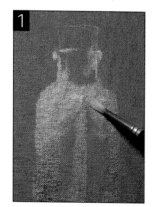
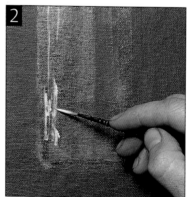
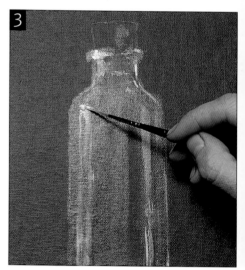

Glaze semi-opaque Titanium White oil paint over a dark surface to form the shape of the bottle. Allow some of the dark surface to show through here and there.

Begin to paint highlights with undiluted Titanium White and a no. 6 soft pointed brush.

Continue painting highlights, making sure that they are really strong on the neck of the bottle. Use plenty of paint!

Other Subjects For Highlighting

Lifting Highlights

You can sometimes create highlights by lifting color, rather than putting it on. Watercolor is an excellent medium to use for trying this technique.

Paint your subject with light watercolor washes, including the areas that will be "lifted."

Paint in the darks, but this time take care not to paint over the areas to be lifted. Use mixtures of Burnt Sienna, mauve, and Prussian Blue. It is important that the dark tones contrast well with the lighter ones.

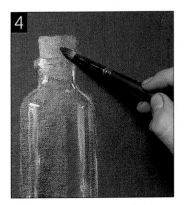

Change to a no. 4 hog's-hair brush and thicker paint, and complete the painting by adding a shelf and the cork.

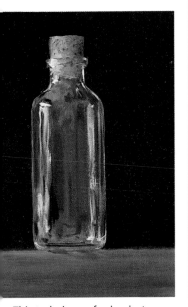

This technique of using just one layer of paint is known as alla prima painting; the highlights created in this way have a singular purity and clarity of light.

Highlighting in gouache

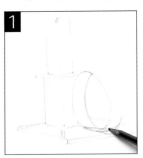

Using a 2B pencil, carefully draw a candle and candlestick on watercolor paper.

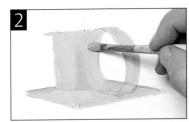

Using a no. 8 hog's-hair brush and a mixture of Yellow Ochre and Burnt Sienna gouache the consistency of cream, underpaint the candlestick.

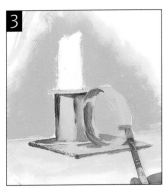

Paint the background in mixtures of Yellow Ochre and Burnt Sienna, leaving the paper white for the candle. Add Burnt Umber to the candlestick to create more form.

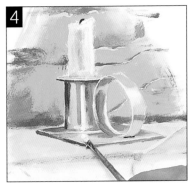

Paint the candle in two or three tones of Payne's Gray mixed with white, add a flick of Payne's Gray for the wick. Paint highlights in white gouache, using a no. 3 sable brush.

The highlights convey the smooth, shiny surface of the brass and emphasize its reflective qualities.

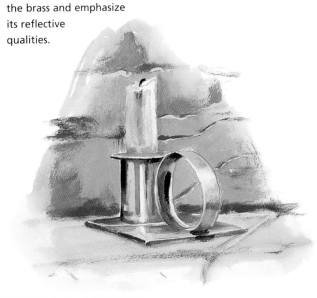

Use a no. 10 nylon one-stroke flat brush, loaded with clear water, to lift off the sunlight on the floor and the highlights on the girl's shoulder and hair. Finally, blot the areas with an absorbent cloth or tissue.

Left
RAYS • Lynne Yancha
(watercolor and acrylic on paper)
This is a beautiful example of highlighting. Rays of light, created by lifting off watercolor, fall onto the boy and cat, emphasizing their place as the main subjects of the painting. White acrylic around the boy's profile adds to the intensity of the highlights.

TECHNIQUE 20 • Frottage

Materials

- Good-quality drawing paper
- Medium-sized watercolor brush
- Range of gouache paints
- Range of soft pastels
- Range of wax crayons
- Range of colored pencils
- Adhesive tape
- Drawing board

Frottage is a term derived from the French verb frotter, meaning "to rub." All you need to do is find a textured surface (such as a piece of wood with obvious grain, or a piece of rough stone), on top of which you place your paper or canvas. Then, simply rub your chosen medium over the paper, and the marks will pick up the underlying texture. All forms of pencils and pastels are suitable for frottage.

Frottage with Mixed Media

Select a rough, well-grained wooden surface. Place your drawing paper on it and rub over the sky area with soft pastels—Cerulean Blue and Pale Yellow at the top, Yellow Ochre at the bottom. Start drawing the sea by rubbing with a light blue colored pencil followed by a dark blue wax crayon.

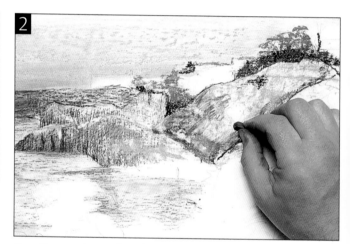

Turn the wooden surface through 90 degrees. Rub Olive Green soft pastel onto the paper for the distant trees, use a medium gray colored pencil and an Ultramarine soft pastel to depict the cliffs, and introduce a hint of Indigo soft pastel into the sea between the cliffs.

Other Subjects For Frottage

Strawberry

This is a simple exercise directed at the less experienced artist. It should enable you to achieve acceptable results quickly.

Lightly draw the outline of a strawberry and place the paper over rough sandpaper. Begin to add color with a red pencil (it requires a reasonable amount of pressure), but leave an area in the top right for a highlight.

Introduce a cleft at the base of the strawberry by increasing the pressure, and paint small leaves in green gouache.

Add more shading at the bottom of the strawberry and a darker shade of green on the leaves, in order to create forms with contrast. Working over sandpaper creates the "dimples" in the strawberry, which could take some time using conventional methods of drawing or painting.

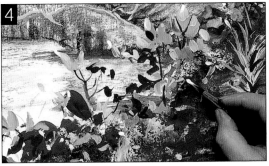

Return the surface to its original position, and rub mauve, brown, and black soft pastels over the bottom right corner.

Draw the trees in black pastel, then tape the paper to a drawing board. Paint the foreground vegetation in gouache, using Lemon Yellow on its own and mixed with Viridian for the lighter leaves, Olive Green mixed with Ultramarine for the darker ones, and Rose Madder for flowers. Add a few highlights in white and leave to dry.

Many items can be used for frottage: lace, sandpaper, a cheese grater, bamboo matting, bubble wrap—use your imagination!

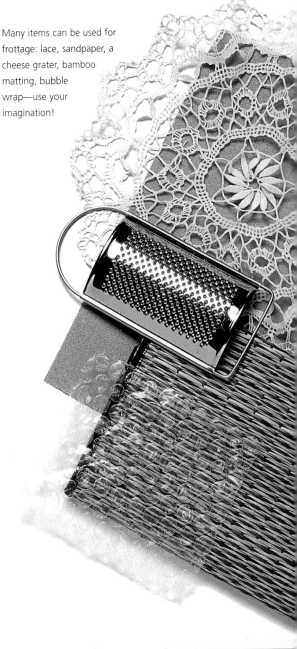

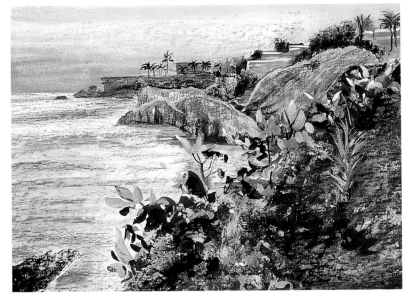

Place the work on the wooden surface again and rub on separately a black and a yellow-green wax crayon to create darker shadow texture near the vegetation. Applying the frottage technique on a wooden surface has created a complete landscape with natural-looking, grainy textures.

Right
UNBORN • Mark Topham
(crayon on lightweight cartridge paper)
This is a very distinct example of frottage, achieved by rubbing with large strokes the sides of crayons on paper on a grainy wooden surface—and the grain shows through wonderfully. The artist used fairly transparent crayons—the perfect medium for this technique.

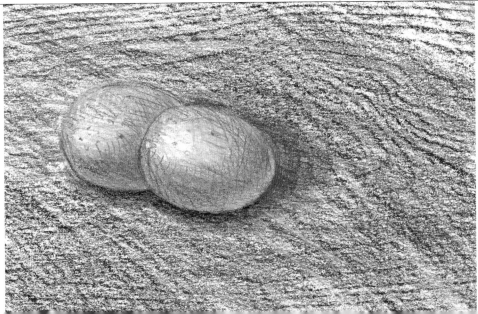

TECHNIQUE 21 • Spattering

Materials

- Watercolor paper
- Range of watercolor brushes
- HB pencil
- Range of watercolor paints
- Range of gouache paints
- Craft knife
- Frisk stencil film

As the name suggests, spattering is a random method of transferring dilute paint from a brush onto a surface. The easiest way to do this is to tap the brush handle with your index finger. Or you can tap the brush on a finger of your opposite hand or on the handle of another brush. You might, however, find there is some "back spray," so be sure to cover your clothes. You can use any painting medium, provided the paint is thin enough to leave the brush.

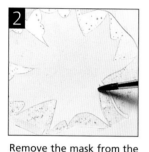

watercolor paint spattered with a no. 6 watercolor brush

Using a mask

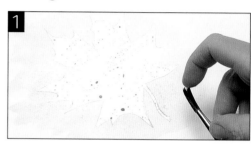

With a craft knife, cut a mask from frisk film and place it over a drawing of a leaf. Spatter light gray watercolor paint onto the background by pulling back the bristles of a soft brush and letting go.

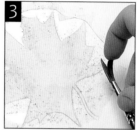

Remove the mask from the leaf and place another mask over the background. Wash a mixture of Burnt Sienna and Raw Sienna watercolor paint over the leaf.

While the wash is still damp, spatter a stronger version of the wash color onto the leaf. Allow the paint to dry and re-spatter: some dots will be blurred and some sharp.

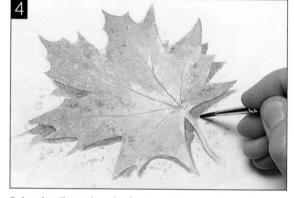

Paint details, such as leaf veins, with a no. 2 round pointed brush, using stronger versions of the leaf colors. Remove the mask, and add a dark gray shadow under the leaf. Spattering has created a natural-looking effect.

Other Subjects For Spattering

Track

Uneven spattering and horizontal brush strokes convey the rough, rutted texture of this country track.

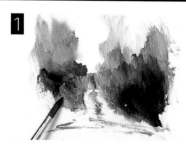

Mask the highlights on the track and spatter masking fluid over the track area. When the masking fluid is dry, paint the background in watercolor washes of Burnt Umber, Ultramarine, and Viridian using a no. 6 brush. Leave to dry.

Using an almost dry no. 6 brush, paint horizontal strokes of Burnt Umber on the track. Be sure to protect the surrounding area, as dots of color will fly in all directions. Then, spatter Burnt Umber onto the track by tapping the handle of the brush.

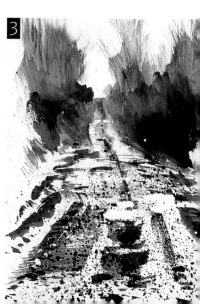

Olive trees in Provence

1 Lightly sketch the olive trees with a pencil. Paint light washes of Cadmium Yellow and Ultramarine gouache around the olive trees, dividing the painting into distinct areas—background, middle ground, and foreground.

2 Turn the painting so that it is in portrait format. With a no. 6 watercolor brush, spatter light greens, Cadmium Yellow and Cadmium Red gouache on the right-hand side.

3 Return the painting to landscape format. Using a no. 2 sable brush, paint fine grasses in the middle ground in mixtures of Ultramarine and Cadmium Yellow. Spatter this area with light greens and Cadmium Yellow.

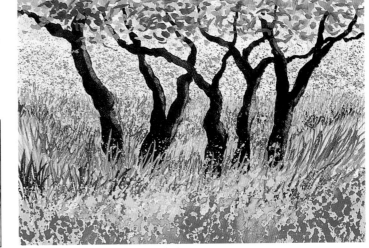

4 Paint the tree trunks in dark mixtures of Burnt Sienna and Ultramarine, making them darker on the left hand side to suggest form. Mix three tones of green from Cadmium Yellow and Ultramarine, and use them to depict the leaves.

5 Using strong mixtures of Cadmium Yellow and Ultramarine, create more grasses in the foreground. Add color to the immediate foreground with a no. 10 hog's-hair brush.

Spatter Cadmium Yellow in the immediate foreground, making sure some of the spattered shapes appear around the trees. Finally, spatter Cadmium Red at the base of the painting; note that the shapes are larger here, suggesting that they are much closer. Spattering unifies the different planes of the painting. The technique also suggests a natural, random approach, which conveys a feeling of life and verve.

Remove the masking fluid. The rough foreground texture contrasts very effectively with the soft background washes.

Left
LEAVES IN THE SAND •
Richard Bolton
(watercolor on paper)
Spattering paint is a wonderful way to portray the granular texture of sand. Here, very fine spattering was used, allowing the leaves to completely disappear in places.

TECHNIQUE 22 • Masking and Resists

Materials

- Watercolor paper
- Range of watercolor brushes
- Range of watercolor paints
- Dark brown oil pastel
- HB pencil
- Candle wax
- Masking fluid
- Masking tape

You usually apply resists to prevent paint from reaching certain areas of the surface. They can also be used to produce a "broken" texture that can be interesting for a wide range of subjects.

Watercolor is an excellent medium to use in conjunction with masking fluid or wax resists. You will find fewer opportunities to use masking techniques with mediums such as oils or acrylics; although masking tape is useful for masking areas in these paintings.

You can use oil pastel, wax crayon, or even an ordinary household candle as effective resists. If you decide to use professional masking fluid and apply it with a brush, make sure you wash the brush afterward.

Creating highlights using resists

1 With a pencil, draw the outlines of the hull, cabin, and mast. Apply masking fluid to the cabin and mast, and masking tape across part of the hull. Leave the fluid to dry. Notice that different resists are used according to the requirements of individual areas.

2 Paint the dark, blue sky quickly with a no. 14 round pointed brush and allow it to dry. Remove the masking fluid with your finger. Now take off the masking tape. The masking fluid and tape have prevented watercolor paint from reaching the paper: there is no sky color in these areas.

3 Paint the beach with Raw Sienna and touches of dilute Burnt Umber watercolor. When this is dry, rub candle wax onto the beach area. Exert reasonable pressure; otherwise, the technique will not work. There must be enough wax to form a resist.

Other Subjects For Masking and Resists

Waterlilies

Masking allows you to use the white of the paper to its full potential, so that the translucent white petals of the lilies appear to glow against the rich blue background of the water.

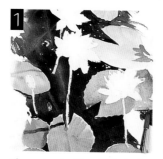

1 Mask the flower heads and stems. When the masking fluid is dry, apply a wash of Prussian Blue mixed with a little Indian Red over the water using a no. 6 round pointed brush. While this is still damp, soften the edges with clear water. Leave to dry. Begin painting the leaves with varying mixtures of Viridian, Gamboge, and Ultramarine.

2 Strengthen the color of the water where necessary. When the paint is dry, remove the masking fluid.

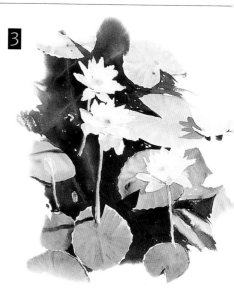

3

Multi-resists with watercolor

1 Apply masking fluid to the hair highlights and candle-wax resist on the chin. Leave until the masking fluid has dried.

2 Mix Yellow Ochre and Alizarin Crimson watercolors and paint a wash over the whole paper. When dry, mix Raw Umber and Cerulean Blue and apply on the left, shaded side of the face.

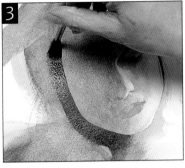

3 Apply a wash of Indian Yellow and Cadmium Red over the face and neck. When this is dry, add a dark mix of Prussian Blue, Alizarin Crimson, and Burnt Umber to parts of the face and hair.

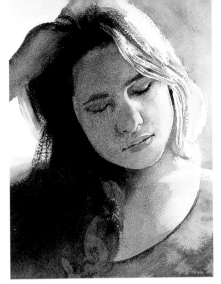

When all the paint is dry, gently rub off the masking fluid. The painting shows the use of two forms of resists: masking fluid for sharply defined highlights on the hair, and candle wax for the more generalized area of the chin.

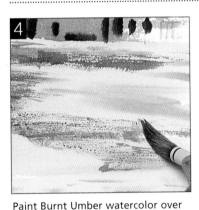

4 Paint Burnt Umber watercolor over the resist area; the result is a dry, broken textural effect, which is ideal for sand and shingle.

5 Use Raw Sienna for the cabin, and a mixture of Ultramarine and Burnt Umber for the hull. To create a worn look to the gunnel, use a dark brown oil pastel. This will pick out the grain on the paper. Paint light brown watercolor over the pastel. The resulting texture resembles the "scuffing" affecting a boat in water.

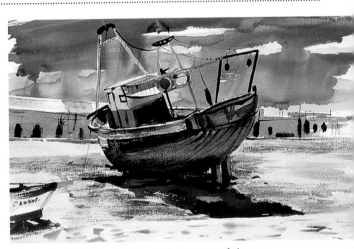

Here is the finished painting, with its array of shapes, shadows, and textures. The tape, masking fluid, and wax resists provide a collection of broken textures.

Using a no. 6 brush and a very pale mixture of Dioxazine Violet and Ultramarine, paint shadows on the white petals. Wet the centers of the lilies and quickly drop in Cadmium Yellow. They will blend at the edges, producing a pleasing, soft effect.

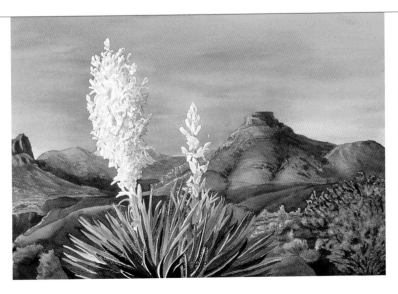

Left
THE GRAND SHOW • Mary Lou King
(watercolor on paper)
Masking the flowers made it possible to paint the sky quickly and spontaneously, without having to worry about paint splashing onto the white blooms. Leaving large areas of white paper to suggest flowers, and using thin, transparent watercolor washes on the foreground leaves help to convey the translucency of the subject.

TECHNIQUE 23 • Aided Texture

Materials

- Watercolor paper
- Range of watercolor brushes
- Range of acrylic brushes
- Range of watercolor paints
- Range of acrylic paints
- Black and white gouache paint
- 2B pencil
- Plastic foodwrap
- Salt
- Stencil film
- Low-tack masking tape
- Natural sponge

You can use all kinds of materials to provide texture in paintings. Some are mixed into the paint itself. Others are pressed onto wet paint and then removed, so you are left with an impression of their texture. Still others are used to screen—or mask—selected areas of your painting so that you can work freely without worrying about paint flowing into the wrong areas. It is not possible to list every idea, but here are a few to get you started.

Crinkled texture using plastic foodwrap

When the paint is dry, remove the plastic wrap.

Using a no. 18 round pointed brush, paint strong mixtures of Cadmium Yellow, Alizarin Crimson, Cerulean Blue, and Ultramarine watercolor onto paper, allowing the colors to blend.

While the colors are wet, place a piece of plastic foodwrap over the wash, and pinch it to create interesting textural shapes.

Other Subjects For Aided Texture

Tree Trunk

Openweave fabrics such as scrim or muslin can be used in two ways to create texture in paintings. You can apply paint through the holes in the fabric, which gives a fairly precise pattern, or press the fabric onto wet paint, which gives a softer effect.

Using a no. 10 hog's-hair brush and loose textural strokes, paint the background in mixtures of Sap Green, Yellow Ochre, and black acrylic paints. Color the tree trunk in Raw Umber. Leave to dry.

Add more of the mixture to the background, and suggest light foliage with a mixture of Sap Green and white. Establish the darker side of the tree trunk with a mixture of Raw Umber and black.

Place cotton scrim or any openweave fabric over the tree trunk and paint through it to create the bark pattern. Press torn strips of scrim, covered with paint, onto parts of the trunk to create more texture.

LAKELAND MOONLIGHT: VARIATION
• **Michael Morgan**
(watercolor on primed,
acid-free board)
Much of the texture in this work
was created after the painting had
been completed. The artist rubbed
selected areas, such as the rockfaces
in the distance and the immediate
foreground on the edge of the lake,
with medium-grade sandpaper,
producing a subtle, broken texture.

The folds in the plastic
foodwrap have created
interesting random
textures in the paint.

Draw on some pencil
lines, which act as guides
for the window shapes.

Use black gouache to create the
effect of the spars and surrounding
window frame. Simple, flat shapes
will suffice; it is the effect of the
glass that is important.

The finished work. Note how the strong
black frame increases the translucent
effect of the stained glass.

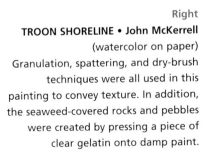

Right
TROON SHORELINE • **John McKerrell**
(watercolor on paper)
Granulation, spattering, and dry-brush
techniques were all used in this
painting to convey texture. In addition,
the seaweed-covered rocks and pebbles
were created by pressing a piece of
clear gelatin onto damp paint.

TECHNIQUE 23 • Aided Texture

Left

THREE GRACES, • Robert Sakson

(aquapasto on paper)

In this painting, the artist created texture in the foreground by using his fingers and arms! First, he applied paint to his fingers and arms and pressed them onto the paper; then he painted the paper with a brush, and pressed his fingers and arms onto the paper to remove some of the paint. Both methods leave an impression of the skin on the paper—an interesting broken texture.

Stencil for texture in small areas

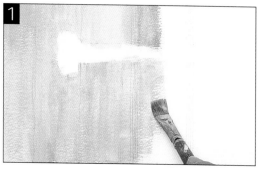

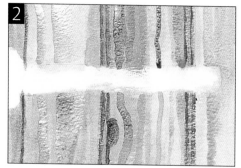

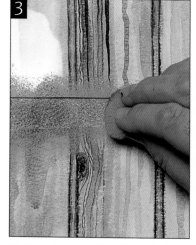

Cut a stencil for a hinge shape from a clear piece of stencil acetate or similar material. Roughly indicate its position on the drawing of a weathered, wooden doorway and begin painting with a brownish-gray acrylic paint.

Continue by introducing detail with a no. 3 round pointed brush and dark gray made by mixing Ultramarine and Burnt Sienna acrylic paint.

Position the stencil on the painting and hold it in place with low-tack masking tape. Load a sponge with Raw Sienna, and sponge on the color. When it is dry, repeat the process with Burnt Sienna. The rust effect should be apparent.

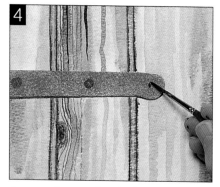

Remove the stencil and add details to the hinge—screws and some shading underneath.

Add some rust stains below the hinge with dilute Burnt Sienna.

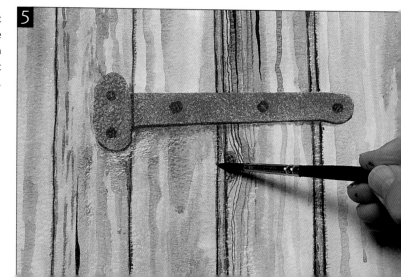

Salt with watercolor

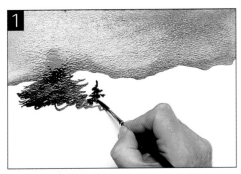

Mix two washes of Ultramarine and Alizarin Crimson, one with more Alizarin Crimson. Use the darker wash for the mountains and the other wash for the sky, using a no. 12 round pointed brush. Paint the pine trees with a no. 4 round pointed brush and a mixture of Ultramarine, Cadmium Yellow, and Burnt Sienna.

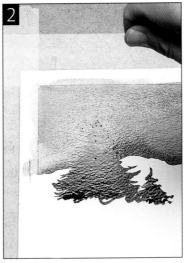

Sprinkle salt, sparingly, over all the wet washes. The salt soaks up moisture and forms crystalline, snow-like textures in the sky and on the trees.

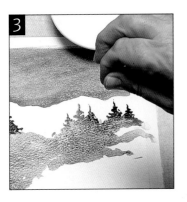

Paint the area under the large trees with a mixture of Ultramarine and Alizarin Crimson. Quickly paint the smaller trees on the right using the same tree color as before. Before the paint dries, sprinkle salt, again sparingly, creating snow-like textures. Allow to dry.

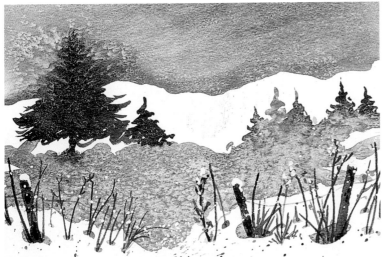

Paint the fence posts and foreground stems with a mixture of Ultramarine and Burnt Sienna, with some stems in Burnt Sienna alone. Top the posts with white gouache. It is very interesting to see how sprinkling salt onto wet watercolor (particularly on colors that granulate—see pages 50–51) provides a crystal-like texture that is perfect for snow.

Autumn leaf

This is an easy way to achieve texture. Simply match the pencil colors with the colors of the leaf itself.

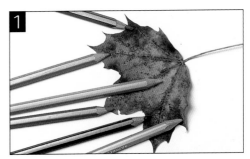

Using a 3B pencil, draw a simple leaf shape on a sheet of watercolor paper and with a small watercolor brush, dampen with tinted water the area inside the outline. Make sure the paper remains wet throughout the work.

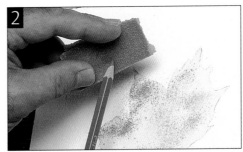

Hold a piece of medium-grade sandpaper over the shape, and rub a variety of colored water-soluble pencils along the grit so that the pencil pigment falls onto the paper. As the pigment comes into contact with the wet surface, it will gently disperse and fix as the water dries.

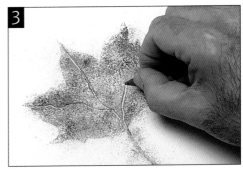

When you have applied enough pigment, use a painting knife to lift out the veins. Then blow away any dry pigment that has fallen outside the "wet" area. Your autumn leaf is complete.

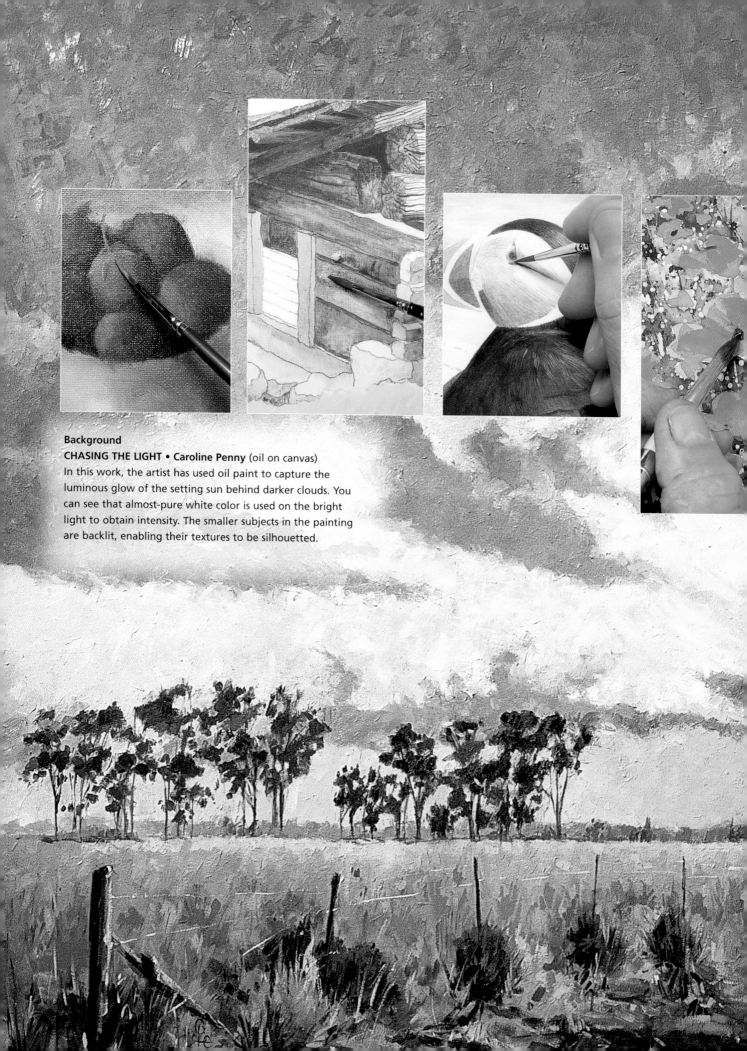

Background
CHASING THE LIGHT • Caroline Penny (oil on canvas)
In this work, the artist has used oil paint to capture the
luminous glow of the setting sun behind darker clouds. You
can see that almost-pure white color is used on the bright
light to obtain intensity. The smaller subjects in the painting
are backlit, enabling their textures to be silhouetted.

Now that you've seen how to create a wide range of textural techniques, it is time to look at how textures can be incorporated into larger-scale paintings. This section consists of a number of themed chapters that you can dip into as the mood takes you.

Each theme contains a detailed step-by-step demonstration designed to encourage you to move beyond the simple practice exercises that you've encountered so far in this book to

THEMES

something a little more challenging. Each demonstration is followed by a "Texture Notebook," which illustrates ways of recording ideas and material that you might like to use in your paintings at a later date.

Work through the themes at your own pace, and in any order you choose. Combined with the techniques that you've already explored, they'll provide you with ideas that you can incorporate into your own work, bringing new life and vibrancy to your paintings.

IN FOCUS • Landscapes

1 Paint distant wild flowers with a series of dots, blurring the texture to suggest distance. Mix watercolor with white acrylic paint to give an effect similar to gouache, and to provide a contrast to the underlying, translucent watercolor washes. The light flowers work well against the dark trees behind them. This is known as "counterchange."

Every landscape is a patchwork of contrasting textures. Rough tree bark or furrows in a plowed field may be set against the jewel-like green of a smooth, grassy meadow; solid granite rocks may be worn smooth by a fast-flowing river; even seemingly fleeting or intangible elements, such as spray from a waterfall, have a textural quality all of their own.

The most fascinating and challenging feature of landscapes is that, far from being fixed and immutable, they are constantly changing with the light. The same scene can look radically different in the space of just a few minutes. Always take time to let your subject "speak" to you before you start work—decide which textures you want to convey in your drawing or painting, and make notes about textures, colors, and the direction of the light to refer to later.

LANDSCAPE WITH FIGURE • Lynne Yancha
(acrylic and watercolor on paper)

2 The stems of plants and wild flowers produce fascinating textures in their own right. Look at the interplay between the light-colored stems and the dark, negative spaces between them. These areas of interplay need careful attention to detail.

3 Stippling is the perfect way to create the texture of plants with lots of tiny flower heads, such as the cow parsley shown here. When painting white flowers, tinting white acrylic with a hint of another color, such as green, is more convincing than using pure white on its own.

1 Light, brittle stems work extremely well against the darker sky. Mask them in the early stages of the painting. When the rest of the painting is complete and the masking fluid has been removed, tint them with a very dilute mixture of Raw Sienna and Burnt Sienna.

TITAN TRIUMPH • Mary Lou King
(watercolor on paper)

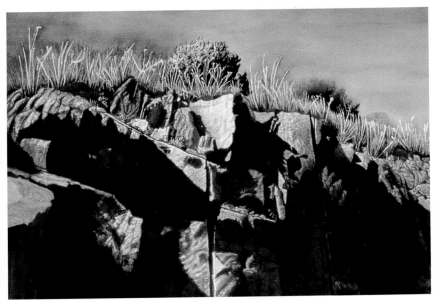

2 Always paint cracks or fissures in rocks in a very dark color in order to make them look convincing. Otherwise they may end up looking like superficial scratches on the surface.

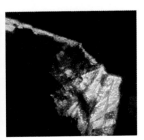

3 In order to make cast shadows work in a painting, contrast is essential. If the chosen shadow color is not dark enough, you will not achieve the right effect.

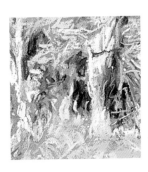

1 There is a real suggestion of sunlight in this area of mainly ochers and yellows. In contrast to the dark tree, the vegetation here is rendered with an overall textural effect and in light colors.

COW AND BROKEN PINE • Bill James
(pastel on paper)

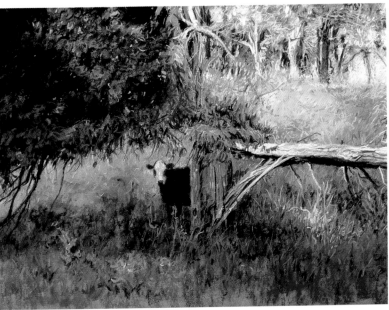

2 Depict foliage with short pastel strokes and a variety of colors. Note how the introduction of a light blue adds a little sparkle, even in a dark shadow area. This helps to keep the foliage texture alive.

3 Use longer pastel strokes for the broken part of the pine, but bend the strokes slightly in order to depict a broken "sinew" of the tree.

THEMES • Australian Gum Tree Watercolor on Paper

Richard Bolton conveys the colors of this Australian sunrise very convincingly, but it is the textures of the tree and shadows that are the important features of this painting. His split-brush method of depicting textured foliage is quite unique, and the warmth and dryness in the leaves is expressed with particular feeling.

Materials

- Watercolor paper
- No. 6 round brush
- 2B pencil
- Masking fluid
- Watercolor paints:

Cerulean Blue

Alizarin Crimson

Ultramarine

Indian Red

Burnt Sienna

Gamboge

Scarlet Lake

Sap Green

Naples Yellow

1 Draw the subject using a 2B pencil and masking fluid on the tree branches. Using masking fluid helps to retain the bleached look of the structure, which is characteristic of gum trees.

2 Wet the paper. Working upward from the center, apply a light mix of Gamboge and Scarlet Lake; working downward from the top, apply Cerulean Blue, making it lighter in tone as it moves toward the first wash. Apply a wash of Gamboge, Scarlet Lake, and Naples Yellow to the lower part of the paper to depict the desert sand.

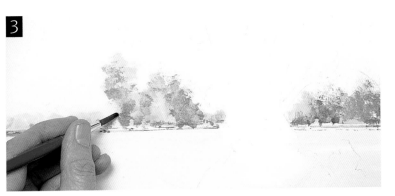

3 Use dry brushwork to create the background scrub and bushes. Mixtures of Naples Yellow, Gamboge, and Sap Green are ideal. Using a no. 6 round brush and mixtures of Burnt Sienna, Indian Red, and Ultramarine, scumble in the dark shadows.

4 Begin painting the tree with a base coat of Scarlet Lake and a little Gamboge. Keep the color light, as this will be overpainted with shapes and shadows at the next stage.

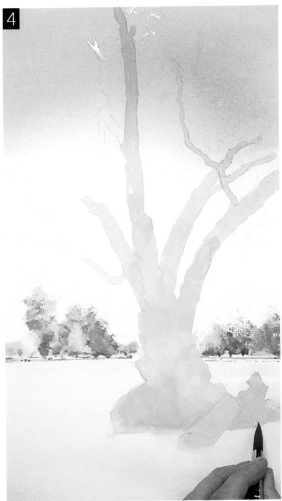

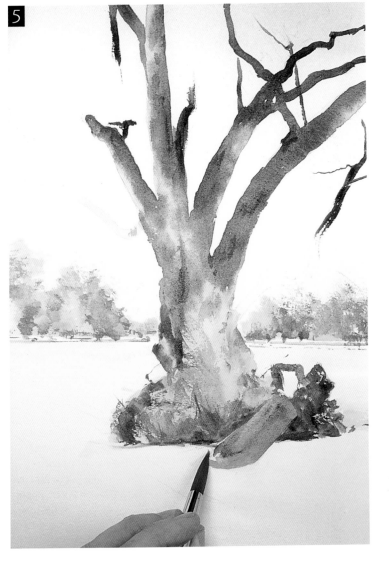

5 Continue painting the tree trunk and branches with both wet-into-wet techniques and dry brushwork to develop textures and subtle colors. Use mixtures of Alizarin Crimson, Ultramarine, and Burnt Sienna.

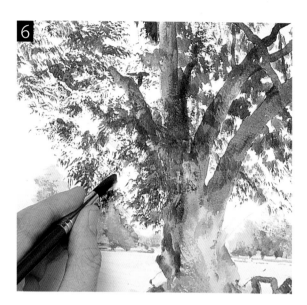

6 Now build up the foliage through "split brush" and dry-brush techniques. "Split brush" requires a delicate touch and a brush that breaks up into many points (a worn, round sable is suitable). Using dark and light greens, dab the brush up and down to create the textures and tones of the leaves.

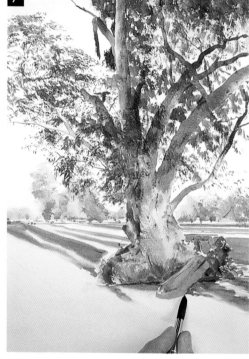

7 Brush in shadows in the sand, using a mixture of Alizarin Crimson, Naples Yellow, and Gamboge. Make sure the surface is wet so that the brushstrokes are soft edged. Use the same colors for textural sand shapes in the foreground.

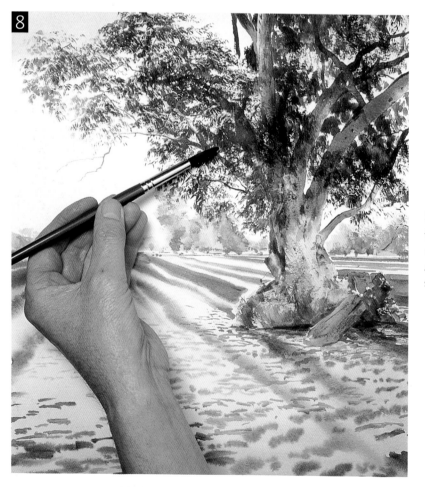

8 Finally, add more texture to the foliage by fine overpainting with a mixture of Naples Yellow and Alizarin Crimson watercolor, and strengthen the foreground colors.

The completed painting shows the effect of early-morning light. Backlighting makes the textures very apparent. The foreground textural shadows, formed by dips in the ground, seem exaggerated, but this adds to the drama.

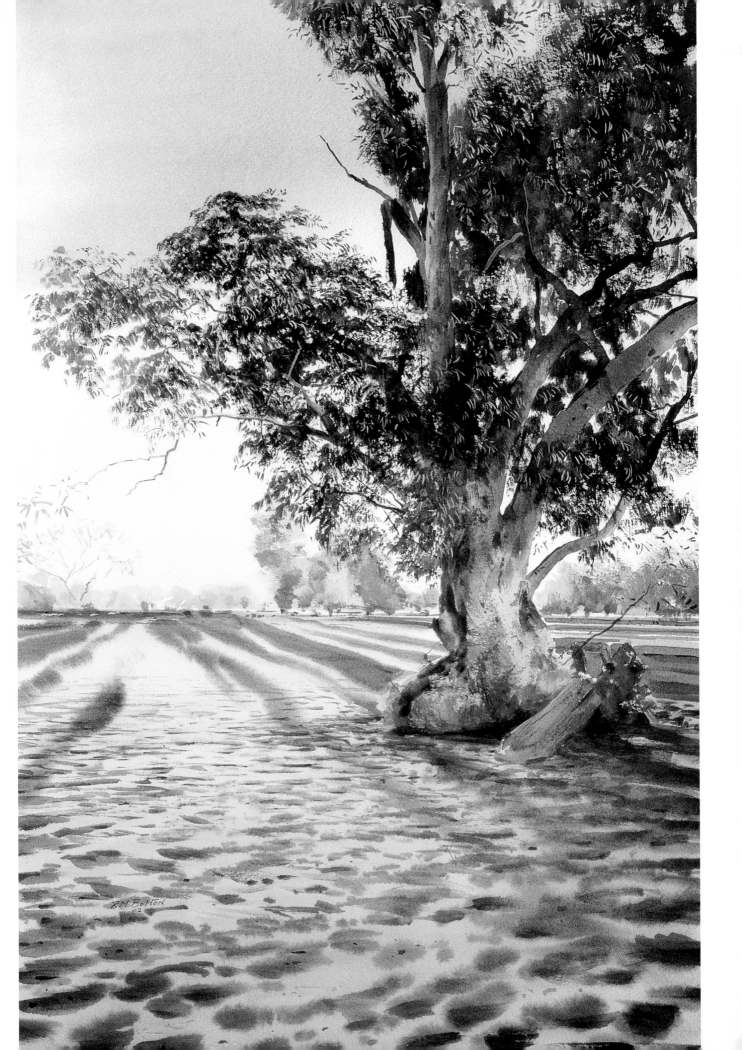

TEXTURE NOTEBOOK • Out in the field

Use small dots of ink to depict small stones and rocks.

Use curved hatching lines to indicate the form of the sandbank.

Collect objects from the location for drawing back in the studio.

Dilute ink with water and apply it with a brush for the reflections on the wet sand.

Blotting the watercolor wash on the sky with blotting paper or tissue produces a dappled texture.

Painting the foreground wet into wet creates both texture and an impression of soft shadows cast by the fence.

Take photographs of landscape details and textures. They will provide you with useful reference material for a later date.

The buildings are painted in a solid color so that they stand out as silhouettes against the light sky.

Michael Warr

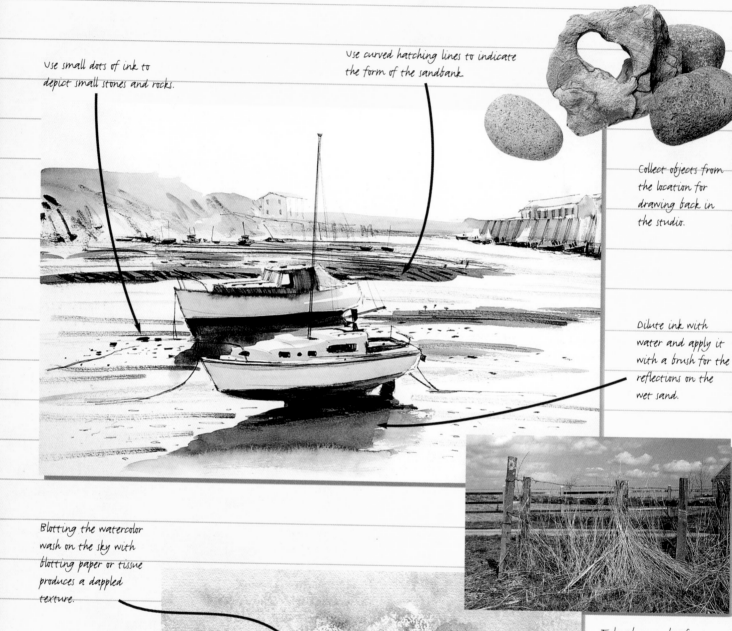

Apply pale sky colors wet into wet so that they merge on the paper.

The broken edges of clouds can be painted effectively using the dry-brush technique.

Mountain Stream
Watercolor

This scene contains a variety of textures, from dappled foliage to rough rocks and sparkling water. The textural techniques used here include applying controlled brushwork, using additives (salt); applying resists; and exploiting the natural granulating properties of particular paints for great results.

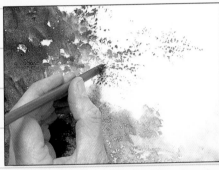

Using a no. 6 round pointed brush, lay washes of Sap Green, Ultramarine, and Gamboge for the streamside foliage, varying the mixtures a little to create a range of yellows and greens. While this is still wet, sprinkle on salt for texture. Allow the paint to dry and build up the leaves, stippling to create texture.

Painting the base of the clouds wet into wet in a darker color gives them weight.

Describing textures in the middle ground or distance requires economy—use only the bare minimum of lines to create bark textures, the skeletal forms of trees, and the mounds of grasses and bushes.

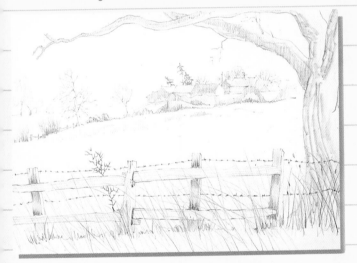

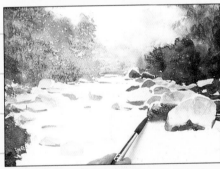

Paint the rocks in a mixture of Alizarin Crimson and Ultramarine. These colors granulate, immediately suggesting texture. Add some masking fluid in the water area to provide highlights. Leave to dry.

Look for old driftwood with worn and gnarled texture—either draw or photograph it for later reference.

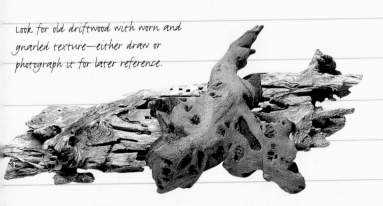

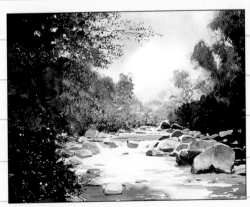

Darken the trees in the immediate foreground, and paint the water in mixtures of Cerulean Blue and Ultramarine, leaving some white paper in the center of the image. When all the paint is dry, remove the salt and masking fluid.

IN FOCUS • Buildings

When it comes to texture, buildings offer more scope than many other subjects. The materials from which they are constructed—from mud, brick, stone, and timber through to corrugated tin, steel and glass, and aluminum—are as diverse as their architectural styles. When these materials weather and age, their potential as subject matter multiplies a thousand times: peeling stucco work, fading paintwork, moss and lichen on roof tiles, bleached timber cladding—the list goes on!

Start by focusing on details of buildings and try to see how they may provide enough material for complete paintings. Remember, recording what you see will also bring pleasure to others; and persuading someone else to see beauty and dignity in decaying plaster or worn and weathered wood will bring you great satisfaction.

FRENCH WINDOW • Kay Carnie
(watercolor on paper)

1 The peeling paint follows the direction of split woodgrain underneath. This is essential in order to portray the effect convincingly.

2 The stonework is successful because of the variety of stone colors used—light, medium, and dark. Note the attention given to the shadows under the separate pieces of craggy stone; very dark color is used to create the impression of the pitted, uneven surface.

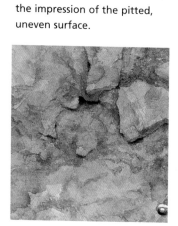

3 Note how the design concertinas on the curtain as it is pushed to one side by the geraniums; the tassels also bunch together at the bottom where they fall into a space.

ST. DAVID'S CATHEDRAL • Naomi Tydeman
(watercolor on paper)

2 Even in dark or shaded areas, strive to include some texture and detail. Otherwise, there will be a "black hole" in the painting. Bear this in mind particularly when you are working from photographs. Unlike the human eye, the camera lens cannot "see" information in the shadows.

1 When painting old buildings, try not to make the stonework look too perfect. Over the years, damage takes place, so make sure you include missing plaster and mortar, or chips and cracks.

3 Including reflections on a polished floor, particularly in this type of building, adds to the sense of grandeur. Note that the reflections are of tall, vertical elements such as archways, emphasizing the great height of the building.

SOHO • Dana Brown
(watercolor on paper)

1 Try to choose buildings with many architectural features. The top of this column adds interest to the left of the painting; its shadow is painted in a mixture of Ultramarine Blue and Alizarin Crimson.

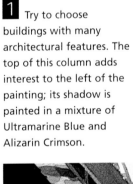

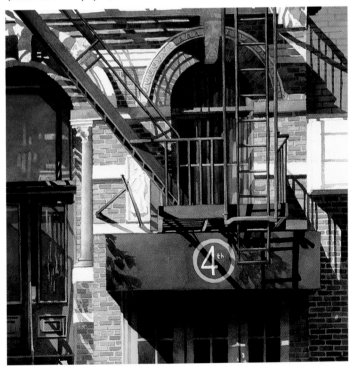

2 The shadows are important in this painting. They appear in so much of it that, in addition to creating interesting patterns, they almost produce the effect of a double image.

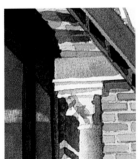

3 Painted onto rusting metal, a number adds poignancy and a personal touch to the painting. The metal is painted with mixtures of Yellow Ochre, Burnt Sienna, and Ultramarine Blue, and the yellow circle in strong Cadmium Yellow.

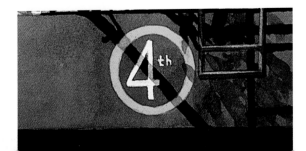

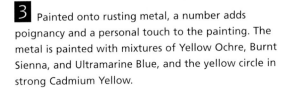

THEMES • Mountain hut Acrylic on Canvas

Materials

- Fine canvas board
- No. 4 round pointed brush
- No. 1 round pointed brush
- No. 12 flat synthetic brush
- 4B pencil
- Acrylic paints:

Raw Sienna
Titanium White
Ultramarine
Cadmium Yellow
Burnt Sienna
Crimson
Burnt Umber

Weathered wood presents us with wonderful material through which to express detail and texture in a painting, and I, as the artist on this occasion, am quite excited by the bleached colors and textural details of this small mountain hut.

The foreground offers the chance to combine free passages with controlled, detailed, textured areas in the building. The alpine flowers provide a final burst of color.

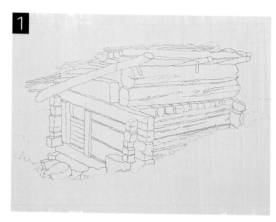

1 Coat a fine canvas with dilute Raw Sienna acrylic paint and draw the main shapes of the hut with a 4B pencil. Include some of the main details, such as the large splits in the wood. These will act as a useful guide at the painting stage.

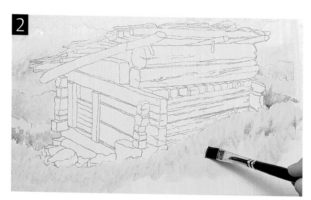

2 Paint the surrounding shapes with fairly dilute paint: a pale mixture of Ultramarine and Titanium White for the sky; Titanium White for the mountains; and Cadmium Yellow mixed with Ultramarine for the foreground greens.

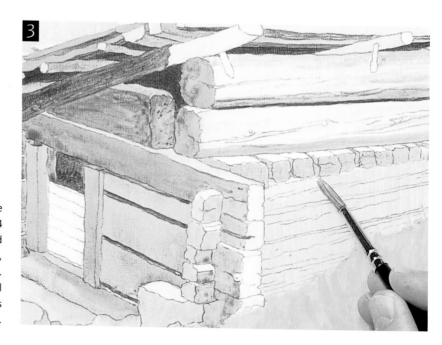

3 Underpaint the hut in the same manner, using a no. 4 round pointed brush and mixtures of Burnt Sienna, Raw Sienna, and pale grays. Note that the strong pencil lines depicting the details are still evident.

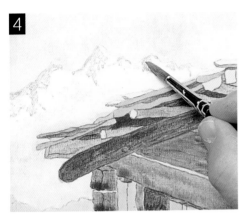

4 Repaint the background with thicker paint, using the same colors, and begin to add detail to the mountains.

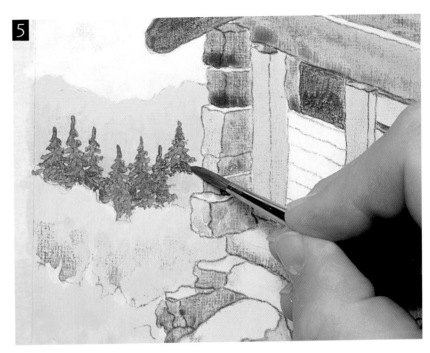

5 Using a no. 4 round pointed brush and mixtures of Cadmium Yellow, Ultramarine, and touches of Burnt Sienna, paint some pine trees in the middle ground. Remember that the trees are in the distance; don't add too much detail.

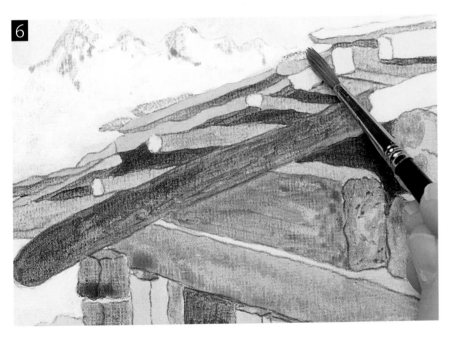

6 Using a no. 4 round pointed brush, add another layer of paint over all the shapes. Make the paint a little thicker than in the early stages—it has better covering power.

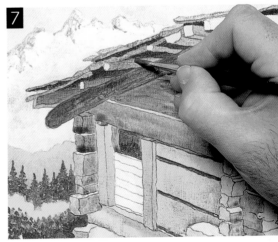

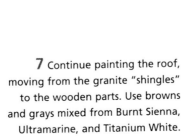

7 Continue painting the roof, moving from the granite "shingles" to the wooden parts. Use browns and grays mixed from Burnt Sienna, Ultramarine, and Titanium White.

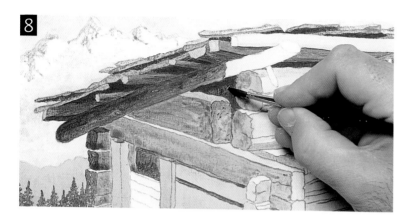

8 Paint any holes in the roof as "negative spaces" using a dark mixture of Ultramarine and Burnt Umber. Make sure the edges are sharp so as to define the surrounding shapes.

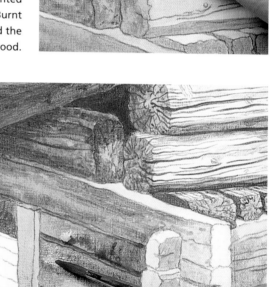

9 Using a no. 1 round pointed brush and a mixture of Burnt Umber and Ultramarine, add the splits and grains in the wood.

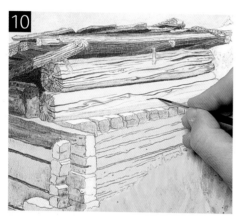

10 Continue adding detail on the large pieces of circular wood until the roof is complete.

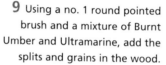

11 Underpaint the lower part of the building in the same way as the roof, varying the colors from rich tans through to cool grays. These provide a good surface for further details.

12 After completing details in the lower part of the hut, begin painting the immediate foreground using a no. 12 flat brush and Cadmium Yellow tinted with Ultramarine. Stipple the paint, making sure the consistency is fairly thick.

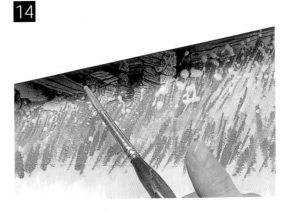

13 Using the edge of a no. 12 flat brush and a mixture of Ultramarine, Cadmium Yellow, and Titanium White, paint vegetation in the form of spiky leaves and stems. These shapes form the basis for a general impression of alpine flowers.

14 Spatter the flowers with separate applications of Cadmium Yellow, pink (mixed from Crimson and Titanium White), and Titanium White. Use a paper mask so that the paint is not accidentally spattered into surrounding areas.

The main textures in this painting are on the building—the cracks and splits in the wood, and the craggy stone roof. It is not a good idea to fill the whole painting with detail and texture: paintings need contrasts if they are to work successfully.

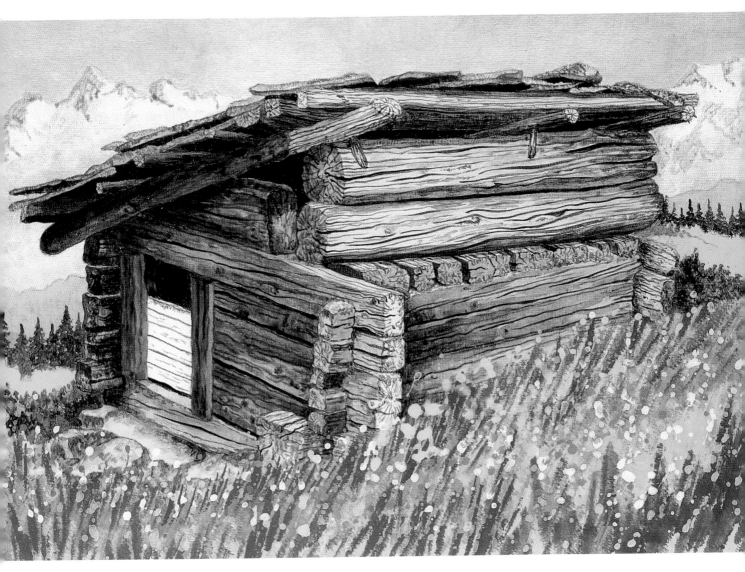

TEXTURE NOTEBOOK • Out in the field

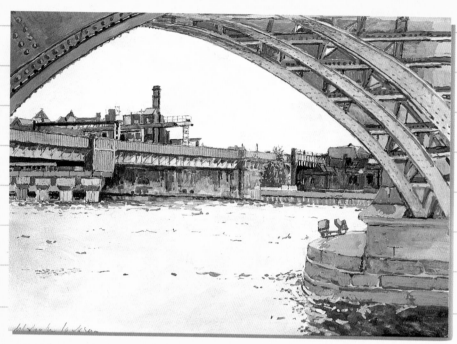

Old weathered bricks are full of texture and details—observe as many different types as possible.

Convey the textures of distant buildings very simply; a mere indication of detail is sufficient. Structures that are closer to you need to be treated in more detail to make them look convincing.

Styles of brickwork vary enormously, so look carefully at the way the courses are laid.

In this kind of derelict building, what's missing can be as important a part of the story as what's there. Use a 4B pencil to softly shade areas where tiles have fallen off, revealing the dark interior of the building.

Indicate the outside edges of tiles with horizontal and short diagonal lines.

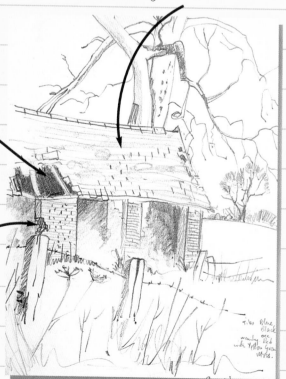

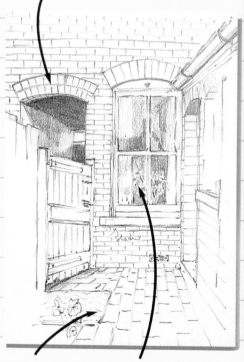

Strong pencil lines in the brickwork suggest that mortar is crumbling away.

Follow the rules of perspective. Make sure that shapes traveling toward you are larger than those in the background.

Record reflections in the windowpanes with light pencil shading. Note that objects near the window are light in tone.

Photograph reflections whenever possible—keep them in a file for future reference.

Crosshatching suggests the texture of the net curtains inside the window.

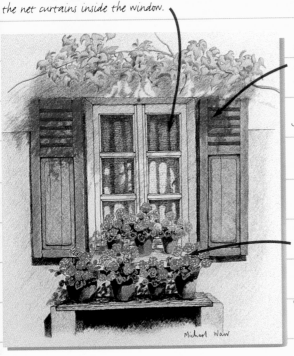

Michael Warr

Include texture and detail even in the shadows. Otherwise, your work will appear bland.

Stippling creates the texture of the geranium blooms.

Photographs of parts of buildings are extremely useful. They provide not only details and texture, but also the information that helps to convey the "feel" of a building, enabling you to appreciate the overall structure.

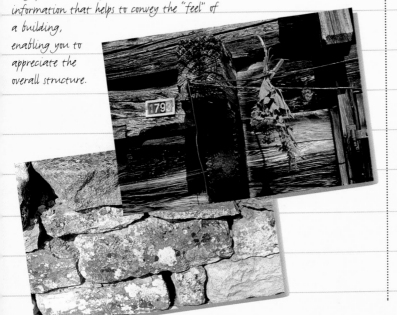

Doorway
Candle Wax Resist With Watercolor

Using candle wax is a great way of creating texture with watercolor. The wax repels the paint and the resulting broken texture is perfect for old, worn subjects such as this barn doorway.

Very lightly sketch your subject and rub candle wax onto the area where the door will be. Paint loose washes of Ultramarine, Raw Sienna, and Alizarin Crimson, allowing the colors to mix on the paper.

Add detail to the doorway. Use Prussian Blue with a touch of Indian Red for the dark interior, and Burnt Sienna for the rusty door hinges. Mix Ultramarine with Raw Sienna for the green "staining" on the door and paving stones.

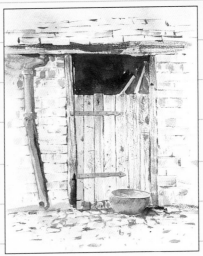

Mix Ultramarine with Burnt Sienna and paint the details in and around the door, in the brickwork, and on the paving stones. Finally, paint the shadows with a mixture of Ultramarine tinted with Alizarin Crimson.

IN FOCUS • Flowers, Plants, and Trees

The textures of plants and flowers are staggering, and close inspection of even the most common species will reveal incredibly complex and intricately patterned structures. And the wonderful thing is that we don't have to travel far afield to find them. Urban parks and gardens can contain enough subject matter to last a lifetime, and even a bunch of common, pre-packed flowers will provide a wealth of material for your drawings and paintings.

Flowers and plants vary with the seasons, too. Not only are there dramatic changes in structures, as deciduous trees and shrubs grow and then shed their leaves, but textures and colors change. You don't even have to paint a tree or plant in its entirety; a single leaf in flowing fall colors, or a piece of tree bark, or twisted tree roots is enough for a small painting.

As always, drawing and painting details is a good way to start. It will help you to sharpen your observational skills and provide you with a wealth of material for larger-scale works.

1 Capture colorful fall leaves by mixing mediums—pastel, acrylic, and gold leaf. Apply the gold leaf at the very end of the painting; it imparts a wonderful glow to the surrounding colors.

AUTUMN TEXTURES • Maureen Jordon
(acrylic, pastel, gold leaf)

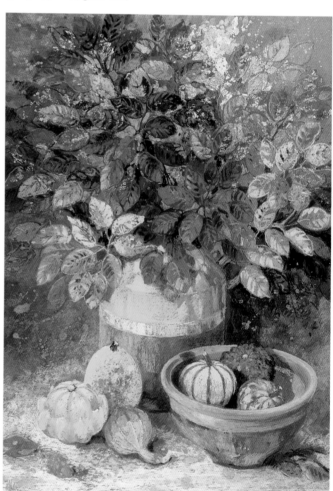

2 One very useful way to create unity in a painting is to echo in one area of the painting the colors used in another area. Here, the colors of the container echo the colors used for the leaves.

3 Gourds in a terracotta pot introduce different shapes, forms, and textures to accompany the shimmering display of leaves. Paint their knobby surfaces by stippling thick acrylic paint.

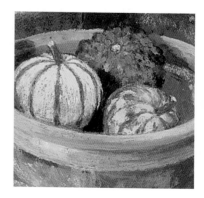

1 Tint the bleached, dead stems with just enough very dilute color to stain the paper. Their light, brittle texture stands out all the more clearly against the surrounding dark color.

COSMOS • Mary Lou King
(watercolor on paper)

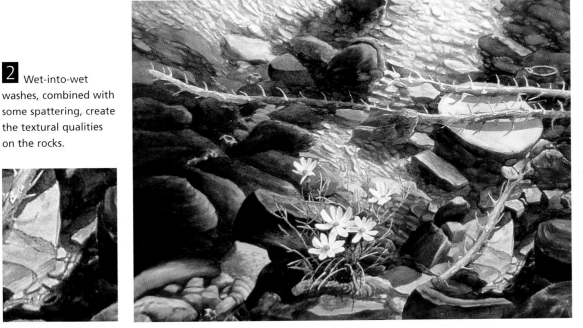

2 Wet-into-wet washes, combined with some spattering, create the textural qualities on the rocks.

3 Paint the delicate, pink daisies in a flat, translucent wash of very dilute Alizarin Crimson. This allows them to stand out texturally from their dark, more heavily painted surroundings.

AZALEAS WITH PINES • Bill James
(pastel on paper)

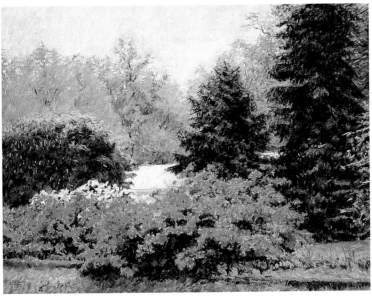

1 The blurry distance is created by blending the soft pastel strokes with a finger and by using cool, light blue-greens.

2 The contrasts of light and dark create the texture of the azaleas. Short pink and crimson pastel strokes are used for the flowers, and dark blacks and greens for the underlying foliage.

3 The colors used on the ground under the azaleas echo those used elsewhere in the picture, unifying the painting.

THEMES • Poppy Field Watercolor on Paper

Materials

- Heavy watercolor paper
- No. 3 round pointed brush
- No. 6 round pointed brush
- 3B pencil
- Masking fluid
- Toothbrush
- Watercolor paints:

Ultramarine

Winsor Blue Green Shade

Cadmium Lemon

Quinacridone Red

Burnt Sienna

Winsor Blue

Cadmium Red

Payne's Gray

Raw Sienna

Phthalo Green

This poppy field offers Joe Francis Dowden the opportunity to convey textures in an expressionist style. There is plenty of wet-into-wet painting and spattering here. Masking fluid is used extensively, allowing plenty of freedom in the early stages of the painting. Joe works in this way in order to combine freely-applied texture with the detail that appears at a later stage of the painting. The result is an amazing carpet of color and textures, produced with great verve!

1 With a 3B pencil, draw the horizon line and poppy heads, making them small in the background and larger toward the foreground. Paint them with masking fluid, using fine spatter for the far distance. Note that there is very little sky in this painting.

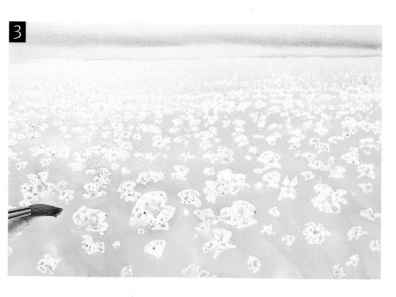

2 With a no. 6 round pointed brush, paint the sky wet into wet, using Quinacridone Red in the lower part, then Winsor Blue Green Shade, and finally Ultramarine along the horizon. Allow to dry.

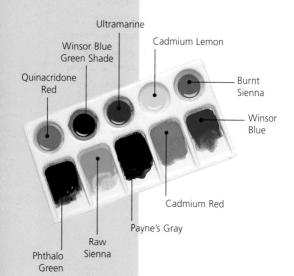

3 Wash Cadmium Lemon over the entire field, using your no. 6 round pointed brush to make rough brushstrokes in the foreground. While this is still wet, introduce Burnt Sienna in the middle and foreground. Allow to dry.

4 Spatter more masking fluid into the foreground and draw broken lines of fluid with a shaper. Leave to dry.

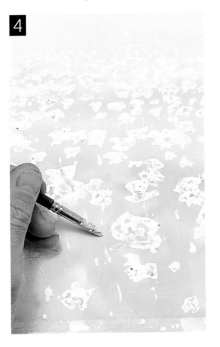

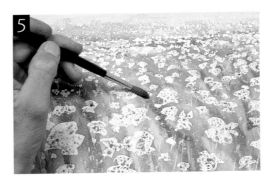

5 Wet the field area and loosely brush in vertical strokes of a yellowish green, Cadmium Lemon, Burnt Sienna, and a little Phthalo Green.

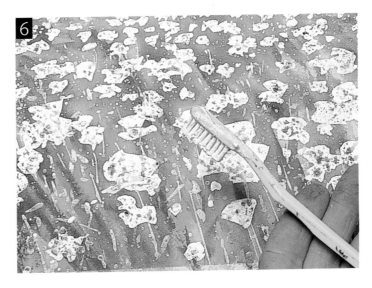

6 Using a toothbrush, spatter masking fluid into the foreground. The aim is to produce as much texture as possible.

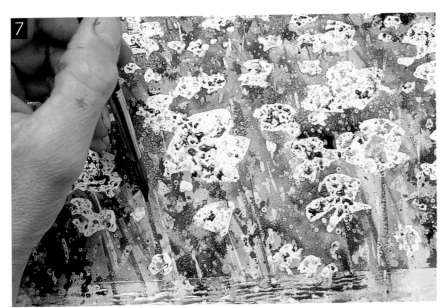

7 Re-dampen the foreground and brush in strokes of a darker green, Burnt Sienna, and a stronger Phthalo Green. Note that the brush marks begin to suggest shapes and forms in the grass.

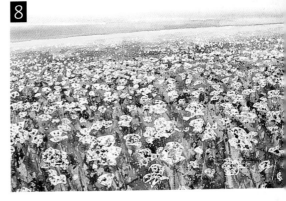

8 Still using the no. 6 round pointed brush, wash in the distant hills with Ultramarine mixed with Cadmium Lemon and a touch of Burnt Sienna.

9 Using the no. 6 round pointed brush, depict the distant trees with a mixture of Ultramarine and Raw Sienna. When this is dry, use Cadmium Yellow to suggest highlights on the darker part of the trees. Note how Ultramarine in the sky creates a darker effect on the horizon.

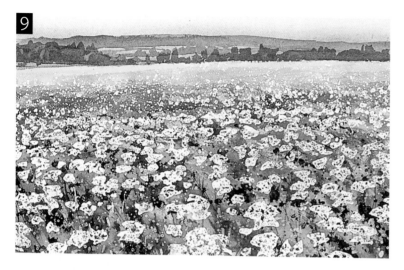

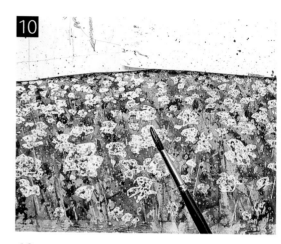

10 Mask the sky, and then spatter a mixture of Payne's Gray and Phthalo Green in the immediate foreground. Allow to dry completely.

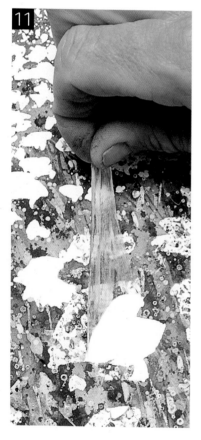

11 Carefully remove all the masking fluid, taking care not to tear the watercolor paper surface. If the surface is damaged, subsequent layers of paint are difficult to apply and the painting loses its freshness.

12 Now change to a no. 3 round pointed brush and paint the poppy petals with Cadmium Lemon, keeping within the white shapes if possible. A little "overspill" is permitted, but not too much! Leave to dry.

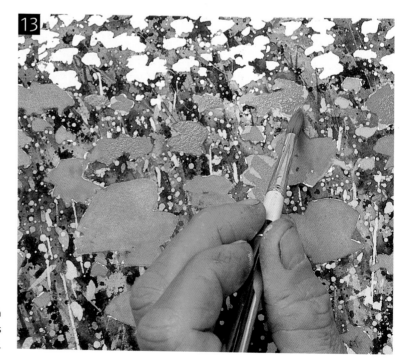

13 Paint over the poppy petals in Cadmium Red, and model darker reds with Quinacridone Red.

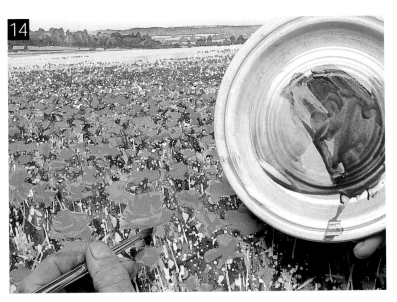

14 Where necessary, add shadows in a mixture of Ultramarine and Quinacridone Red. This process is only needed on the nearer, more detailed poppies.

The painting is a carpet of color, but the use of spattering has kept the textures looking natural and random. Far from being botanical studies, the flowers appear vividly alive, wavering in the wind.

15 Finally, using a mixture of Payne's Gray and Winsor Blue, paint the poppy centers.

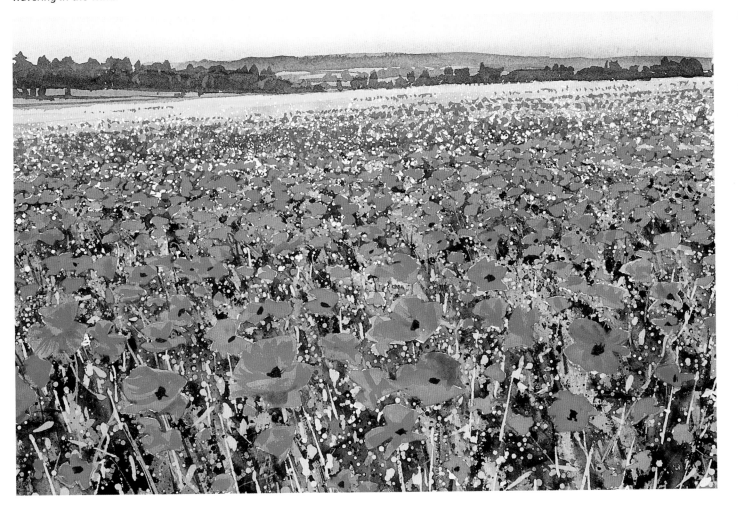

TEXTURE NOTEBOOK • Out in the field

Close observation is
essential when
painting flowers.
Hold paint colors
next to your
subject for an
accurate match,
if necessary.

Dry, crinkly leaves provide very good
subjects for texture work. Collect
them to draw later in the studio.

Flwers are an invaluable source of
textural information. Just draw or
sketch some of them.

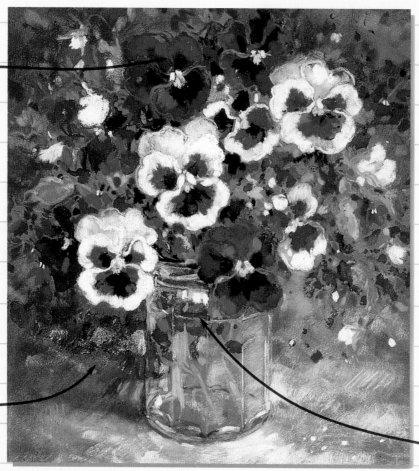

Allow the background
to merge with the
surface on which the
subject rests; it gives
the sketch unity.

Use gouache to record highlights
on subjects such as glass.

Hatched pencil lines imply
the texture of bark.

Take photographs of natural textures
for reference purposes. See how this
photograph relates to the sketch of a
tree. The photo provides extra
information which, when combined
with a sketch, can be used as
reference material for a more
elaborate drawing or painting.

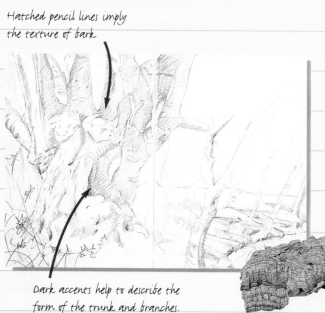

Dark accents help to describe the
form of the trunk and branches.

Use water-soluble crayon to record petals quickly, and then blend with water. When the pigment dries, a textural residue will remain.

You don't need to paint the surrounding vegetation in great detail: a few simple strokes of the crayon are enough to put the flowers in context.

Wet-into-wet and spattering techniques provide a textured foreground, out of which flowers and plants may emerge.

Michael Wam

Use dark hatching to describe the dark side of a leaf.

Light, delicate rose petals require little pencil work; simply indicate the shapes and shaded areas.

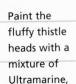

Glass has a texture; it is smooth. Use soft, continuous shading to indicate the shape and form of the vase.

Domestic Thistles
watercolor

Here, flowers are seen against old wooden cladding—giving you the perfect opportunity to practice a range of texture techniques in the same study.

Draw the flowers with a 2B pencil. Wet the background and quickly add Cerulean Blue mixed with Burnt Sienna. While this is still very damp, paint the shadows with a mixture of Ultramarine and a touch of Alizarin Crimson. As the background dries, drybrush Sap Green vertically over the boards in order to create the grain of the wood.

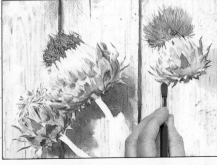

Paint the fluffy thistle heads with a mixture of Ultramarine, Alizarin Crimson, and a touch of Burnt Sienna. When this is dry, scratch out individual hairs with a craft knife. Paint the spiky scales at the base of the flower heads with two mixtures: Gamboge Yellow and Raw Sienna, and Ultramarine and Alizarin Crimson.

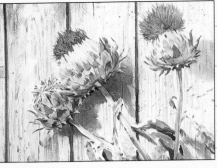

Paint the leaves in a mixture of Cerulean Blue, Ultramarine, and Emerald Green, and the stems in a mixture of Gamboge Yellow with a touch of Cerulean Blue. Keep the leaves vague to focus attention on the flower heads and their prickly textures. Note that the background texture is also vague, ensuring that the flower heads stand out clearly.

IN FOCUS • Still Life

For many people, the words "still life" conjure up images of dull, boring objects simply placed on a tabletop. Nothing could be further from the truth!

Still-life subjects can be found anywhere, at any time, indoors and outdoors, in the most unexpected of places. An old gate or a mailbox might inspire you, or battered tools in a garden shed. Colorful fruit and vegetables on a market stall, kitchen utensils, scraps of fabric, family heirlooms—the possibilities are endless.

As we are dealing with capturing texture, look out for situations where objects with interesting surfaces may be found. This could take you on an exciting voyage of discovery.

1 Long, soft pastel strokes, blended with the finger, produce the soft, gentle folds in the chiffon curtain.

BUREAU TOP WITH TEA THINGS
• Deborah Deichler
(pastel on paper)

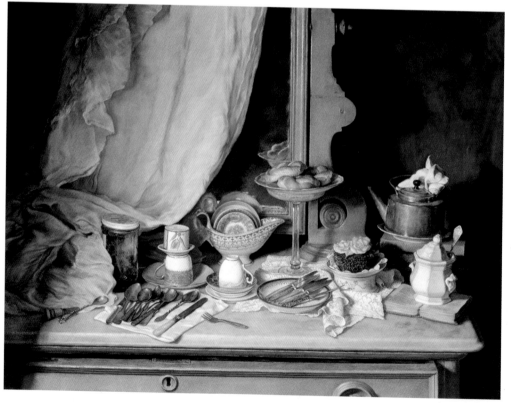

3 Crusty bread rolls are created by stippling, working light over dark for the lighter areas. This produces a slight sheen on the baked surface.

2 Note that the underlying color shows through where the plating has worn on the spoon. This effect is produced by working light color over dark, the opposite way to how the wearing really occurs! Even on the worn area, there is a highlight.

JAR WITH SHALLOTS • Michael Warr
(acrylic on gesso board)

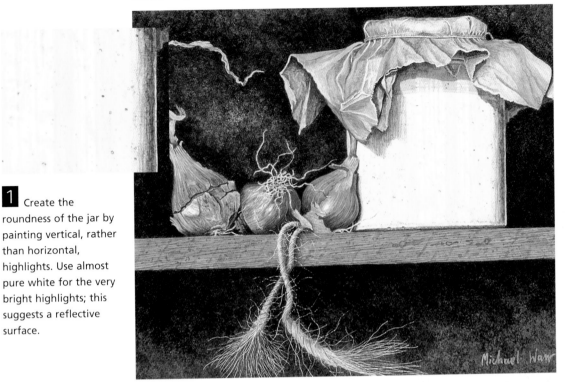

1 Create the roundness of the jar by painting vertical, rather than horizontal, highlights. Use almost pure white for the very bright highlights; this suggests a reflective surface.

3 To create the sheen on the surface of the shallots, glaze light color over dark.

2 As this painting is on gesso-coated board, it is quite easy to exploit the plaster-like surface to create interesting textures. Scratching back through the paint to the gesso surface with a sharp craft knife is a great way to convey the fraying sisal. The underlying surface is white, but you can tint it with very dilute color.

MINOR INDISCRETIONS • Barbara Dixon Drewa
(oil on wooden panel)

1 At first glance, the painting appears to be framed with maple molding, but this is a *trompe l'oeil*. The frame is painted, as can be seen from the fact that the corners of objects protrude beyond the perimeter of the frame.

2 Soft blending with a soft brush creates the flat, smooth paper finish of the envelopes. Changes in tone depict the folded areas, producing an excellent three-dimensional effect.

THEMES • Strawberries on Striped Cloth Oil on Canvas

Materials

- Canvas board
- No. 4 round pointed sable brush
- No. 8 round pointed sable brush
- No. 2 round pointed sable brush
- Charcoal
- Soft cloth
- Turpentine
- Craft knife
- Oil paints:

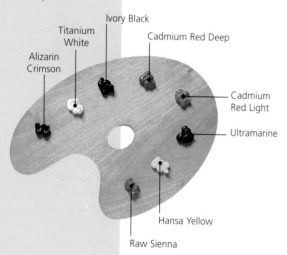

Alizarin Crimson

Titanium White

Ivory Black

Cadmium Red Deep

Cadmium Red Light

Ultramarine

Hansa Yellow

Raw Sienna

Brian Gorst really tempts our taste buds in his painting of strawberries. They appear so succulent, and he captures their texture so well; there is even a spoon, complete with highlights, which entices us to help ourselves. His attention to texture and detail is wonderful as he manipulates the oil paint in a very special way, using soft sable brushes throughout, which gives the surface quality of the thick paint an interesting, soft appearance.

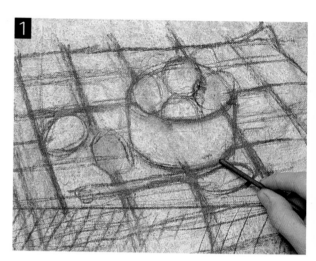

1 Paint the canvas pink with a mixture of Alizarin Crimson and Titanium White. When it is completely dry, lightly sketch the subject in charcoal, taking care to establish the geometry of the cloth pattern accurately.

2 With a soft cloth, gently brush off any loose charcoal, leaving a ghost image on the canvas.

3 Paint the background in Titanium White and grays made by mixing Titanium White and Ivory Black. Use soft sable brushes throughout the painting in order to avoid harsh brushstroke marks.

4 Block in the basic strawberry colors in Alizarin Crimson, Cadmium Red Deep, and Cadmium Red Light. Use a dark gray for the spoon.

5 With a soft cloth, rub out some highlights on the fruit, revealing the ground layer of paint.

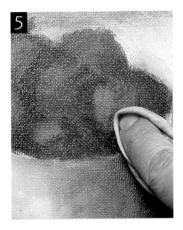

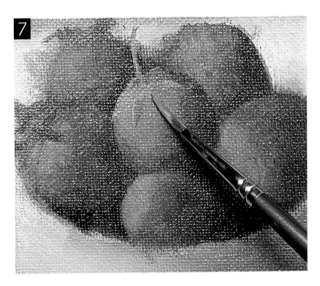

6 Paint the dark areas on the inner edge of the bowl with a mixture of Alizarin Crimson and Ultramarine.

7 Using a mixture of Hansa Yellow and Ultramarine, paint the stalks and their small shadows on the strawberries.

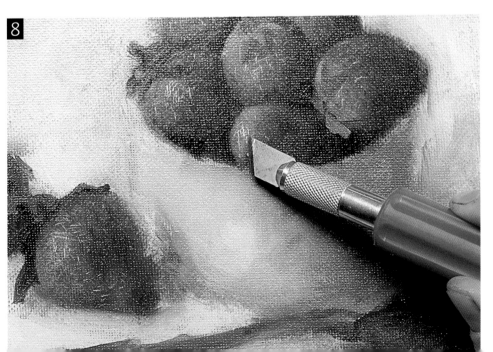

8 Using a craft knife, scratch out highlights in the wet paint making sure you do not scratch right through the paint to the canvas.

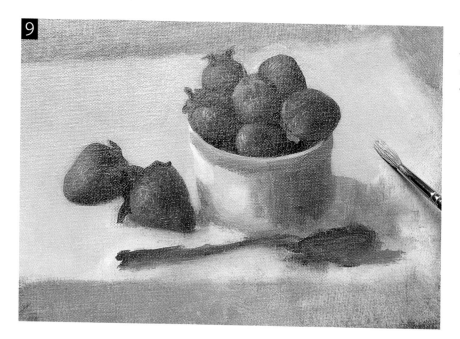

9 Paint the cloth around the strawberries with a mixture of Titanium White and a little Ultramarine.

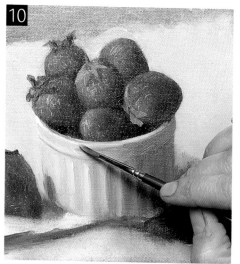

10 Carefully begin painting the bowl with mixtures of Titanium White tinted with Ultramarine and Titanium White tinted with Raw Sienna. Add the highlights with pure Titanium White.

11 Establish a strong crease in the center of the cloth, and begin to paint the pale blue pattern lines with a mixture of Ultramarine and Titanium White. It does not matter if part of the spoon disappears, as it can be repainted later.

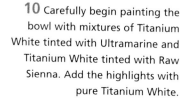

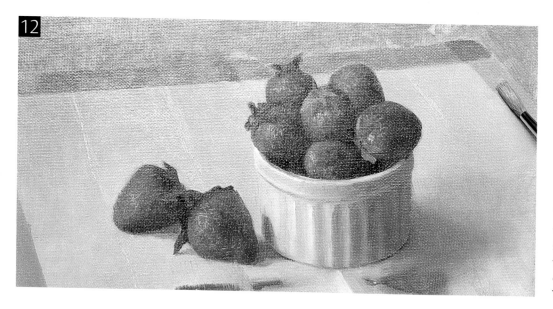

12 Continue painting the cloth pattern, using stronger color around the edge. Use a mixture of Ultramarine and Titanium White.

13 Strengthen the small blue lines with a no. 2 sable brush. Keep a steady hand and strive to be accurate.

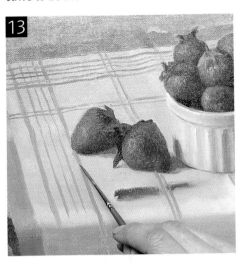

14 Repaint the spoon and add necessary highlights using neat Titanium White.

Finally paint a dark gray background around the cloth. This painting illustrates a meticulous approach to texture, achieved through the use of sgraffito and well placed brush marks. Soft, creamy paint and soft brushes are used throughout.

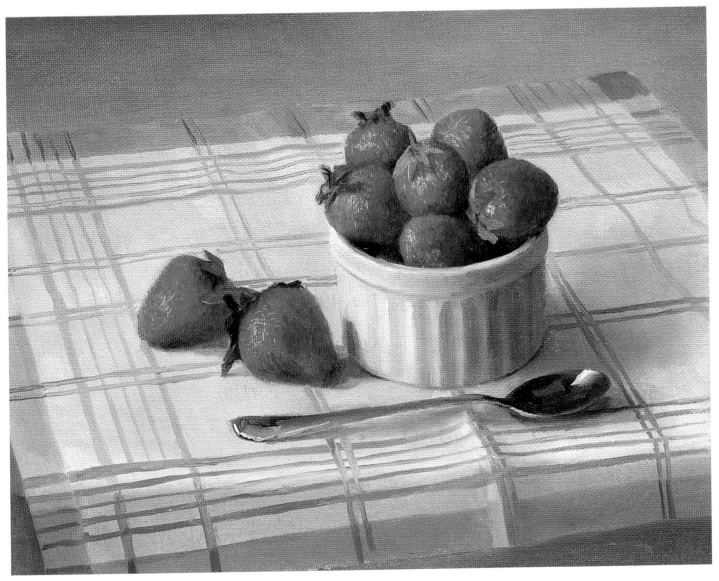

TEXTURE NOTEBOOK • Out in the field

Capturing textures in a limited time frame requires economy of shape and line. To capture the essence of what you see, draw just certain parts of the object, for example, skin and roots. You can add more detail later.

The skins of fruits have many differing textures. They provide excellent subjects for drawing and sketching.

Look around in junkyards—you will be surprised at what you discover!

The beach is a veritable feast for texture enthusiasts—collect as many shells as possible.

A pile of logs can make an ideal study for inclusion in a larger painting and, indeed, a subject in its own right. If you come across a subject like this and don't have time to sketch it, quickly photograph it for reference.

Paint the rusting chromium plating in Burnt sienna watercolor.

Paint the rusting can wet into wet, so that the color spreads.

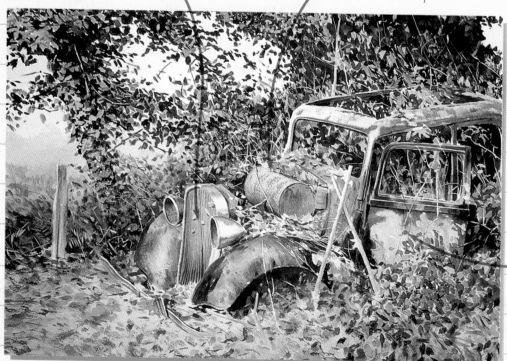

When paint peels, the undercoat is exposed. Use dilute Payne's Gray for the undercoat.

Draw the wooden post with wax oil crayon and wash the background with dark watercolor. The oil acts as a resist.

Stipple the top of the post with dark color to suggest weathering and lichen.

Because a wax resist was used in the first stage, adding more watercolor over the details in the post creates a broken, textured quality.

Enamel Mug and Pitcher
Watercolor

Any objects, in any corner, can offer good material for textural study. Keep your eyes open; these things are all around us! From a textural point of view, rust is a wonderful topic to study; the wet-into-wet technique lends itself very well to this subject.

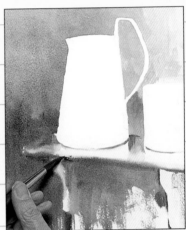

Dampen the paper and brush on a wash of Raw Sienna mixed with a little Ultramarine, carefully painting around the mug and pitcher. Add shadow with a stronger version of the same wash. Allow it to dry.

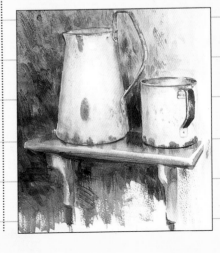

Paint the pitcher and the mug with a very dilute mixture of Ultramarine, Cerulean Blue, and a slight touch of Alizarin Crimson. While this wash is still slightly damp, paint the rust on the pitcher with a mixture of Burnt Sienna and Raw Sienna. The color will spread. As this dries, brush more color into the center of the rust shape and then apply Burnt Sienna to the rusty handle.

Define the wheel spokes by shading the negative spaces between them with a dark-colored pencil, using short pencil strokes.

The use of very dark color suggests shading and slight shadow.

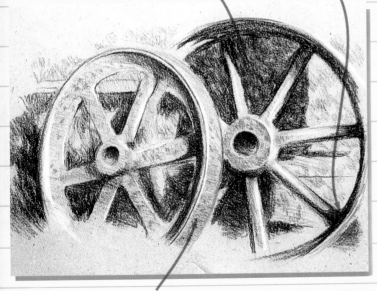

Stipple the rusty rim of the wheels using the point of the pencil. This implies a pitted texture.

Paint the mug in the same way, but depict the handle with strong Ultramarine. Darken the background with a wash of Ultramarine mixed with Burnt Sienna.

IN FOCUS • Animals and Birds

1 Paint the seal's fur in dilute gouache over a darker underlying color. Make sure the lines follow the contours, as this is what gives form to the seal's head.

COMMON SEAL • Paul Dyson
(watercolor and gouache on paper)

Animals and birds offer excellent opportunities for introducing detail and texture into paintings. Fur, skin, and feathers are tactile surfaces just waiting to be explored with any medium.

Pets can be sketched and drawn in the comfort of your home—this is made even easier if you can induce them to remain relatively still! Museums are another useful source of material: they often have collections of stuffed animals and birds, and you get the chance to inspect shapes, colors, and textures closely. Recording wild animals is a different matter and, unless your drawing skills are such that you can sketch on location, you may need to rely on photographs. If wild animals inspire you, a trip to your local zoo may be a good idea. Remember that colored pencils or water-soluble pencils are useful for location work if you wish to capture color in your initial sketches.

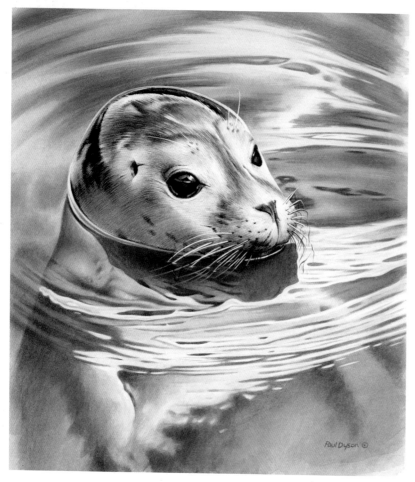

3 Strong white gouache tinted with a little Payne's Gray very clearly defines the whiskers.

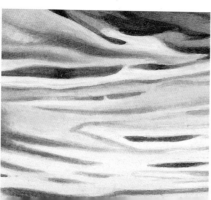

2 When painting ripples on water, make sure that the edges of the shapes are soft. This suggests gentle movement of the water. Note that these shapes are not merely rings of color; they are also the out-of-focus reflections of the seal.

MARINUS • Naomi Tydeman
(watercolor on paper)

1 Create texture in the background by dropping salt and clear water into a dark Indigo wash while the initial color is still wet. This makes an interesting "spread" of color.

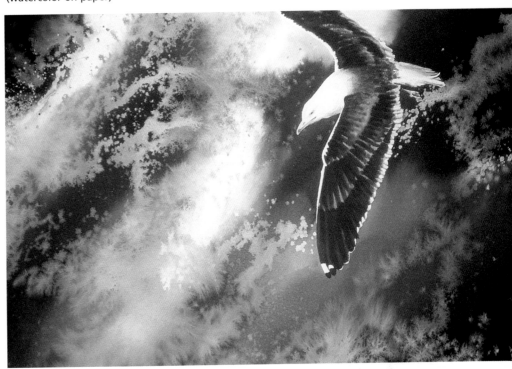

2 Drybrushing on the wing produces the individual feathers. White gouache highlights the tip of the wing, creating excellent contrast against the surrounding dark color. Strong white gouache tinted with a little Payne's Gray defines the whiskers very clearly.

1 To create texture on the face, use a small watercolor brush to make short brushstrokes. Note the attention given to the directional movement of the skin, giving a sense of form to the head.

BENGAL TIGER • Paul Dyson
(watercolor and gouache on paper)

2 Do not paint the dark stripes in one color, but allow the individual hairs in the stripe to continue through onto the lighter-colored areas. Use slightly opaque color to produce continuity.

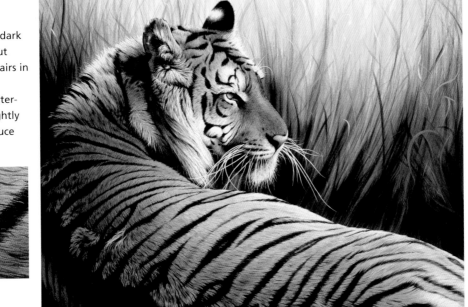

3 A wispy, slightly out-of-focus background gives the tiger definition. The colors are very much in keeping with the main subject, instilling the painting with a sense of unity.

THEMES • Puffin Gouache on Illustration Board

Materials

- Hot-pressed watercolor paper
- No. 2 round pointed brush
- No. 5 round pointed brush
- B pencil
- Masking film
- Craft knife
- Gouache paints:

Ultramarine
Payne's Gray
Flame Red
Indigo
white
Cadmium Yellow
Yellow Ochre
black
Cadmium Orange

Paul Dyson's masterly use of the dry-brush and spattering techniques in this delightful study of a puffin has resulted in a range of very different textures—a sea that really looks as if it's ebbing and flowing, feathers that seem so soft and smooth you could almost reach out and stroke them, and the unyielding and uneven rocks on which the puffin has made its home. His choice of colors thoughout is muted, making the vibrant orangey-yellow of the bill and eye all the more compelling.

Before you embark on a painting, try out different compositions and colors to see what works best. Here are Paul Dyson's initial graphite pencil sketches and a more detailed sketch with color notes.

1

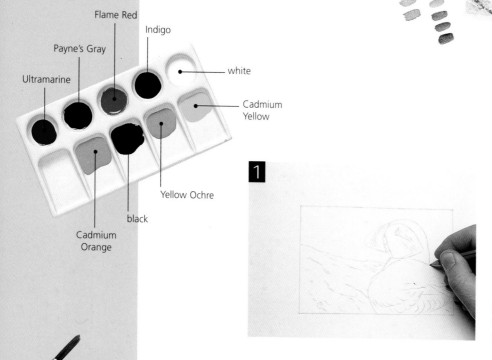

1 Using a B graphite pencil, lightly draw the main outlines of the puffin and rocks.

2

2 Apply masks (see pages 72–73) over the puffin and rocks. This allows you to paint the sea freely, without worrying about the paint spreading into the wrong areas. Dampen the paper and begin painting the sea with dilute Ultramarine, wet into wet.

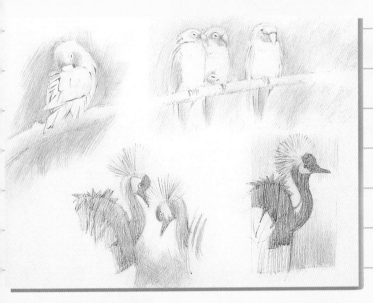

Cat
Colored Pencil

Rather than trying to draw or paint a complete animal portrait, practice capturing the texture by focusing on just one part. Here, short colored-pencil strokes are used to capture the short fur on a cat's head.

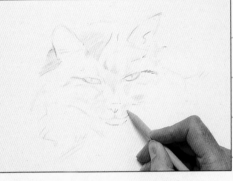

Draw or sketch a few studies on one page of your sketchbook. The birds here mainly rely on quick, light drawing and some hatching. The sketches provide useful information, but the whole page also makes an interesting presentation.

Lightly draw the outline in the main fur colors—Pale Vermilion, Tan Orange, Burnt Sienna, Violet, and Deep Brown. Maintain light pressure to cover larger areas, and make sure the pencil strokes follow the direction in which the fur grows. Keep your pencils sharp at all times.

Use light hatching and minimal lines to describe the texture on the back of the baby crocodile.

A simple eye captures the character of the reptile.

Observe the position of the legs. This is extremely important in capturing the pose and characteristics of any animal.

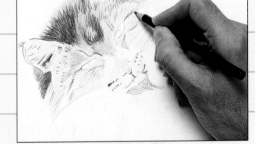

Build up the color on the cat's head, working over the underlying colors with shorter strokes in a darker tone. Then, go back over the drawing with lighter colors so that they blend.

Here you see snakeskin (below) and fur (right). Look closely at animal coats, and use them as exciting textural references.

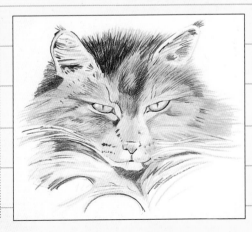

Complete the drawing by using a touch of white pencil to lighten the white of the whiskers and the eye.

IN FOCUS • Figures and Portraits

LITTLE GIRL • Lynne Yancha
(watercolor and white acrylic on paper)

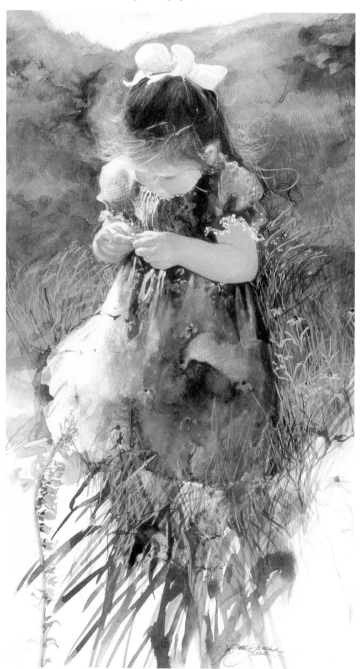

1 Paint hair caught in the breeze with flowing, fine brushstrokes to imply movement.

2 Highlights on the hands help to focus attention on the flower that the girl is examining intently. Paint them in white acrylic on top of watercolor.

Figures and portraits present us with many challenges. Figures may be clothed in many differing fabrics, all bringing with them an array of details and textures. Work clothing, leisure and sportswear, formalwear—there are so many choices!

If you initially find the thought of getting someone to pose for you a little daunting, work from photographs of your family or friends, or even of your favorite movie stars. Look for interesting hairstyles, make-up, or wrinkles to provide good textural qualities in the painting. You could begin with drawing or sketches; then move on to finished pieces of work in your preferred medium.

Backgrounds are necessary in some form but should always be used to enhance rather than detract from the main subject. In the case of portraits, simplicity is the order of the day—a simple background will ensure that the interesting features of a portrait have more impact.

3 Some lovely wet-into-wet techniques are used to paint the dress. White acrylic mixed with Indigo produces the desired effect. Note how the contrast between light and dark is important here.

LÜTSI • Michael Warr
(acrylic on gesso)

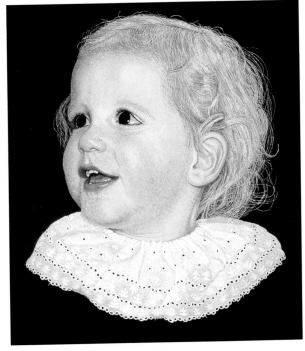

1 Soft stippling with a small sable brush creates the smooth, soft skin of the baby. There is a blush on these young cheeks, so the color moves from pale pink to pale crimson.

2 Use the sgrafitto technique for fine, wispy baby hair; scratch back into the dry paint with a craft knife and then re-tint, if necessary, with very dilute color.

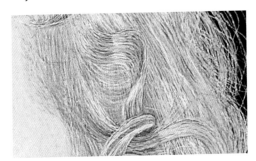

3 The open embroidery collar is important in this portrait. Note how subtle colors are used to depict the pattern work. The holes are painted with very dark color to show the garment underneath.

1 When you are painting furrows on a face, you need to give them three-dimensional form. Otherwise they will just look like painted lines. Paint the dark line first; then, immediately above it, paint a middle tone and, above that, a light tone. This will make a furrowed brow look more convincing.

A MAN LOOKING OVER HIS SHOULDER
Deborah Deichler
(oil on gesso board)

3 To paint the edge of the beard, drybrush light gray whiskers using short strokes and a flat brush. This also allows the beard to stand out against the very dark background.

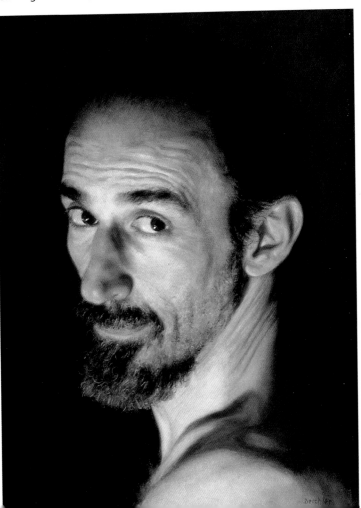

2 Stippling with a small brush creates the stubble between the sideburns and beard. Note how the stubble follows the wrinkled contour of the face.

THEMES • Portrait of Una Watercolor on Rough Paper

Materials

- Heavy watercolor paper
- No. 2 round pointed sable brush
- No. 6 round pointed sable brush
- No. 10 mop brush
- 2B pencil
- Watercolor paints:

Watercolor portraits are always a challenge. Glynis Barnes-Mellish always uses this medium with great style. She manages to retain a fresh look in her paintings, despite the fact that she applies several washes. In this painting the detail and textures are captured without loss of paint clarity. Look at the hair: It is portrayed with the minimum of information, but we feel the volume and texture, as the shapes are played off against the "out-of-focus" dark, textural background.

1 Draw main shapes of the face with a 2B pencil. Keep the lines light, as they will absorb into the painting as it progresses.

Ultramarine
Sap Green
Burnt Umber
Burnt Sienna
Light Red
Alizarin Crimson
Raw Sienna
Cerulean Blue
Prussian Blue
Yellow Ochre
Cadmium Red

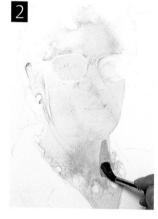

2 Using a no. 10 mop brush, apply the first wash of Alizarin Crimson mixed with Yellow Ochre. Cover the whole of the face, but not the highlights in the eyes and hair.

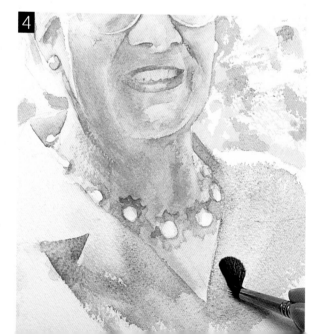

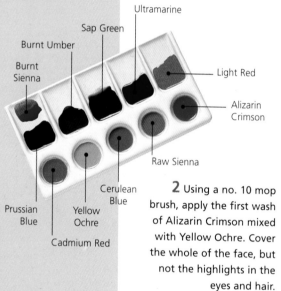

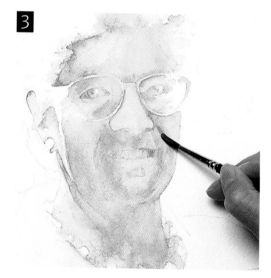

3 Brush on a second wash with mixtures of Alizarin Crimson, Yellow Ochre, and Cerulean Blue. This is the modeling stage and brings out slight relief of the face. Keep the colors clean by not overbrushing.

4 Introduce bright colors, using mixtures of Cadmium Red and Raw Sienna, and Alizarin Crimson and Cerulean Blue. Use these colors to describe the physiology of the face, the initial stage of the blouse, and the necklace.

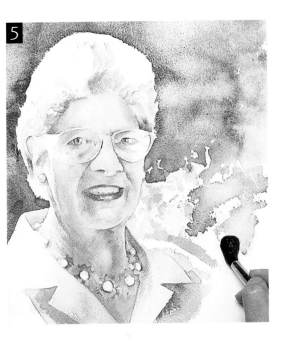

5 Wet the background and feed in a mixture of Ultramarine and Light Red. While the area is wet, drop in Sap Green and Burnt Sienna. These colors granulate, providing a stone-like texture. Introduce foliage on the right-hand side with mixtures of Sap Green, Raw Sienna, and Burnt Sienna. Note how the dark background creates an excellent foil for the light gray hair.

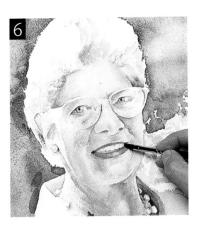

6 Mix Burnt Umber with Prussian Blue and use a small pointed brush to define structure and detail in the face. Paint the lips with Alizarin Crimson.

7 Use the same colors and technique to define the necklace and blouse. Try not to overwork these areas, as the painting is nearing completion.

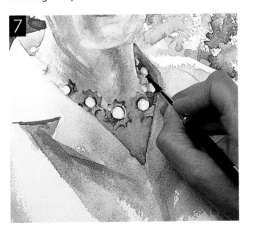

Drybrush the same colors onto the stone wall and onto the face to create final dark tones and textures. A combination of dry-brush techniques and the clever choice of granulating colors creates the textures in this painting. The overall effect is soft and gentle, in keeping with the subject.

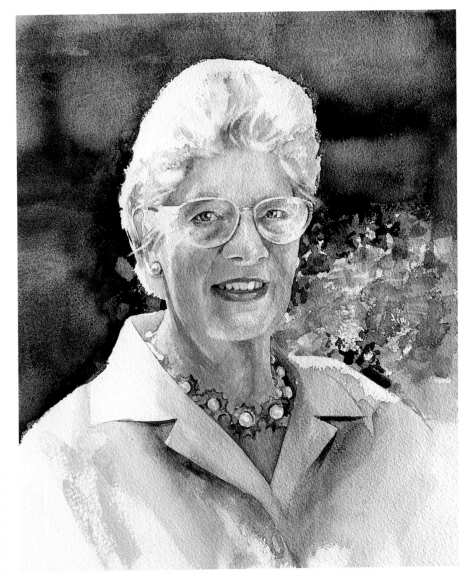

TEXTURE NOTEBOOK • Out in the field

Use wriggling pastel strokes in the hair—light on dark suggests fine strands.

To create textures on the back, use layering and blending techniques. Note the "broken surface" effect on the right shoulder.

Folds in fabric are always a challenge. Observe the shapes and shading closely so that you can really appreciate their forms.

Add a highlight on the thigh using very light color applied with a positive, single stroke.

Dilute ink, applied with a brush, produces the volume of hair.

Water is dropped into wet ink, and lines are hatched to suggest the texture and form of the thigh.

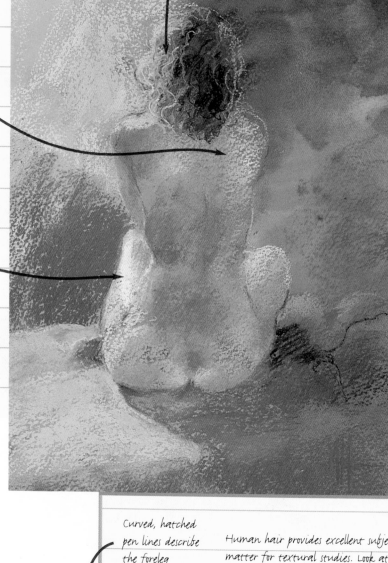

Curved, hatched pen lines describe the foreleg and foot.

Human hair provides excellent subject matter for textural studies. Look at the growth patterns and draw them—this will make your work more interesting and more convincing.

Hand
Gouache

Use light and dark tones in a 2B pencil to depict the folds in the denim.

Light and dark hatched lines depict the uncomplicated hairstyle.

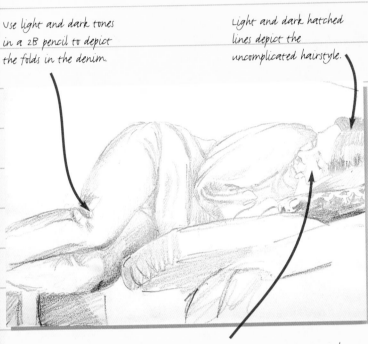

Keep the features to a minimum—the subject is asleep. Simple, curved lines describe the closed eyes.

Spectacles are manufactured in a wide variety of styles—sketch as many types as you can. This activity will help your portrait work immeasurably.

If you can't persuade anyone to sit for you, try a self-portrait. Use a soft pencil and work quickly. Try to capture the expression in your eyes, but remember that you are looking in a mirror and the image will be in reverse.

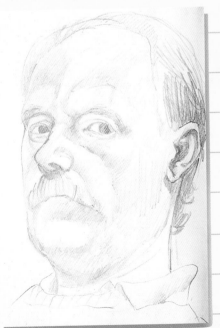

Small color studies or sketches of parts of a figure can be extremely useful for future reference. Try persuading a relative or friend to act as your model, and make a quick study of a hand. A close-up like this is a great way of learning to observe the details and texture of skin, and it is quick to do.

Using a 2B pencil, draw the hand. Paint the hand in a mixture of Yellow Ochre, Cadmium Red, and white gouache. Allow this to dry and paint on dilute white to create a lighter color on the back of the hand. Using a no. 2 round pointed brush, paint details with a mixture of Madder Alizarin with a touch of Yellow Ochre, and white. Allow it to dry.

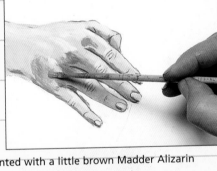

Using a flat no. 3 hog's-hair brush, scumble a mixture of Yellow Ochre and white tinted with a little brown Madder Alizarin onto the little finger and the back of the hand.

Paint a mixture of Yellow Ochre and a little white to depict the surface on which the hand is resting. Use a separate mixture of Madder Alizarin, Lemon Yellow, and a little white to form the background and define the shape of the hand.

Index

Figures in *italics* indicate captions.

Credits

Quarto would like to thank and acknowledge the following for images reproduced in this book:

Key: t = top, b = bottom, l = left, r = right, c = center.

Theresa Bartol 16. Glynis Barnes-Mellish 3tl, 50t, 66/67b, 73t, 122–123. Richard Bolton 2tl&tc, 4/5b, 24br, 32tr, 34br, 44bl, 46bl, 70/71b, 72/73c, 72b, 82–85, 86tl, 87tl & r, 95r, 103r, 110bl, 111bl & r, 118tl, 124bl. Bob Brandt 57bl, 65bl & br. Dana Brown 53cl, 89b. Kay Karnie 88. Deborah Deichler 104, 121b. Barbara Dixon Drewa 48tr, 105b. Paul Dyson 20t, 24t & l, 26t, 33tr, 42/43c, 47tl, 70t, 112, 113b, 114–117, 119tl. Joe Francis Dowden 98–101. Mary Anna Goetz 63bl & bc. Robin Gray 23b. Brian Gorst 1bl, 2/3, 22/23t, 28/29t, 47br, 48c & 49 t & c, 66t & 67tl, 106–109. Malcolm Jackson 43tc, 94t. Bill James 18cr, 21br, 29bl, 39cr & bl, 40br, 81b, 97b. Maureen Jordan 96, 102tc, 124tr. Mary Lou King 73bc, 81t, 97t. Michael Lawes 19tl, 27br, 41br. Jack Lestrade 51b, 59br. Midori K Luck 118b. Lydia Martin 49br, 55cr. John McKerrell 75br. Michael Morgan 75tl. Caroline Penny 78. Ron Ripley 31br, 37b. Robert Sakson 76tl. Ian Sidaway 1cl, 26b, 30b, 38b, 56b, 64b, 74b. John Storey 18/19b, 21tr & bl, 28b, 32b, 34/35t, 36/37t, 41bl & t, 45t, 119r. Mark Topham 15cb, 19br, 20b, 22b, 25c & b, 27t, 29tr, 30/31t, 32/33c, 36b, 37tr, 38/39t, 40t, 49tr, 56t, 57t, 60b, 62b, 64t & 65tl, 67tr, 68t & 69t and b, 102bl, 103bl, 119cl, 125. Naomi Tydeman 89t, 113t. Michael Warr 1tl, 2tr, 15ct, 33bc, 35bl, 42/43b, 44 t & br, 45b, 48b &49 bl, 50b, 51t, 52, 53 tl & r, 54, 55 t, cl & b, 58, 59t, 60t, 61, 62t, 63t, 65tr, 68b, 71t, 74/75c, 76/77, 86cr & b, 87cl, 90–93, 94cr & b, 95cl & bl and r, 102br, 103tl, 105t, 110tc & br, 111tl, 121t. Janet Whittle 25t. Lynne Yancha 6t, 67bc, 80, 120.

Quarto would also like to thank the artists who demonstrated for photography:
Glynis Barnes-Mellish, Richard Bolton, Paul Dyson, Joe Francis Dowden, Brian Gorst, John Storey, Mark Topham.

All other photographs and illustrations are the copyright of Quarto Publishing plc. While every effort has been made to credit contributors, we would like to apologize in advance if there have been any omissions or errors.